www.wadsworth.com

www.wadsworth.com is the World Wide Web site for Wadsworth and is your direct source to dozens of online resources.

At *www.wadsworth.com* you can find out about supplements, demonstration software, and student resources. You can also send email to many of our authors and preview new publications and exciting new technologies.

www.wadsworth.com
Changing the way the world learns®

COLOR
BASICS

STEPHEN PENTAK
The Ohio State University

RICHARD ROTH
Virginia Commonwealth University

THOMSON
™
WADSWORTH

Australia • Canada • Mexico • Singapore • Spain • United Kingdom • United States

For my parents and my students who have taught me much.
S. P.

For Beatrice and Helmuth.
R. R.

THOMSON
WADSWORTH

Publisher: Clark Baxter
Executive Editor: David Tatom
Art Editor: John R. Swanson
Assistant Editor: Amy McGaughey
Editorial Assistant: Rebecca F. Green
Technology Project Manager: Melinda Newfarmer
Marketing Manager: Mark Orr
Marketing Assistant: Kristi Bostock
Advertising Project Manager: Vicky Wan
Project Manager, Editorial Production: Trudy Brown
Print/Media Buyer: Kristine Waller

Permissions Editor: Joohee Lee
Production Service: Elm Street Publishing Services, Inc.
Photo Researchers: Sandra Lord and Cheri Throop
Cover Designer: Preston Thomas
Cover Image: Annie Mae Young (1928-), *Strips* or *Strip Quilt*. Corduroy, c. 1975. 95 × 105 inches. Collection of the Tinwood Alliance. Photo: Steve Pitkin/Pitkin Studio.
Cover Printer: The Lehigh Press, Inc.
Compositor: Lachina Publishing Services
Printer: Courier Corporation/Kendallville

For more information about our products, contact us at:
Thomson Learning Academic Resource Center
1-800-423-0563

For permission to use material from this text, contact us by:
Phone: 1-800-730-2214
Fax: 1-800-730-2215
Web: http://www.thomsonrights.com

Library of Congress Control Number: 2003101947

ISBN 0-534-61389-6

Wadsworth/Thomson Learning
10 Davis Drive
Belmont, CA 94002-3098
USA

Asia
Thomson Learning
5 Shenton Way #01-01
UIC Building
Singapore 068808

Australia/New Zealand
Thomson Learning
102 Dodds Street
Southbank, Victoria 3006
Australia

Canada
Nelson
1120 Birchmount Road
Toronto, Ontario M1K 5G4
Canada

Europe/Middle East/Africa
Thomson Learning
High Holborn House
50/51 Bedford Row
London WC1R 4LR
United Kingdom

CONTENTS

FOREWORD

The overarching message of *Color Basics* is sensitivity! Art and design require sensitivity, attention, and awareness. For example, they require:

- Sensitivity to the fact that between two very similar blues, one might be warmer, the other cooler; one intensely blue, the other duller; one darker, the other lighter; one a tint, the other a shade.
- Attention to the fact that a color may appear to float above the surface, or that the edge between two colors may disappear in one area and vibrate with great intensity in another.
- Awareness of the fact that our ideas about color are contextual and are influenced by the cultural notions of our time and place.

To see that color is chameleon-like—such as when observing a brown becoming intensely red when placed against a blue-green background—is really to see your own mind at work! Simultaneous contrast, afterimages, vibrating boundaries, interpenetration, and optical mixture all offer glimpses of human perceptual processes, processes that remain incompletely explained by science.

Color Basics is a guide to the numerous qualities of color and their application to practice. Be sensitive to color . . . explore and enjoy.

PREFACE

Color Basics evolved from an ongoing dialogue between the two authors on the subjects of color, art, and education. We started with a respect for the contributions of such artist/educators as Albers and Itten, among others. We also took the model of *Design Basics* as a guide for organizing and presenting concepts in a clear, well-illustrated way. The modular format allows for a flexible use of the book and easy cross-reference between sections.

A primary objective of *Color Basics* is to present a broad array of color concepts of interest to artists and designers, and to do so in a way that demystifies the complexity of the subject. The human response to color will always be complex and mysterious, but most of what we observe and know can be shared in an uncomplicated language based on shared experiences. We would like the modular sections of this text to work both as a visual glossary for color concepts and as signposts pointing to possibilities for more extensive research and creative work.

We are grateful for the contribution of a number of people in our efforts to compose a useful text. Help and guidance have come from colleagues and students alike, and we would like to thank them for their assistance. Mike Amrhein, Matt Kenyon, Ryan Mulligan, and Andrew Garrett assisted with research and provided the reality check of a student's point of view. Ardine Nelson set us straight on photography questions. Joe Gaffney helped us track down an obscure source. Jamie Pentak created diverse and "well-tuned" color graphics. John Swanson and Rebecca Green provided continuous encouragement and editorial guidance. The quality of our efforts was also assisted by the rigorous scrutiny of the following reviewers:

Timothy App, *Maryland Institute College of Art*
Judy Brazil, *Johnson County Community College*
Shun Endo, *The Ohio University–Lancaster*
Paul Ryan, *Mary Baldwin College*
Georgia Strange, *Indiana University*
Sandra Williams, *University of Nebraska–Lincoln*

COLOR BASICS

CHAPTER 1
INTRODUCTION

EXPERIENCE OF COLOR

What is our experience of color? Is color a quality of surface or light? Is our experience of color simply the mechanics of our perception, of our eyes and nervous system? Does the experience evoke associations or act symbolically? Do we struggle to name an elusive quality? In fact, color works in all of these ways on our senses and imagination.

"Red." Is this the color of the sun at sunset? An experience leading to a blue-green **afterimage?** A symbol suggestive of passion or anger? Which "red" would we choose—scarlet or crimson **(A)?**

Color enriches and complicates our experience and communication. It is a visual experience but is attributed to musical instruments (the "color" of a trumpet in contrast to a woodwind) and thoughts ("His attitude is colored by a childhood experience"). Our emotions are labeled by color: We might say someone is "green with envy" or "feeling blue."

Consider this passage from Helen Keller's biography:

> I understand how scarlet can differ from crimson because I know that the smell of an orange is not the smell of a grapefruit. I can also conceive that colors have shades and guess what shades are. In smell and taste there are varieties not broad enough to be fundamental; so I call them shades. . . .The force of association drives me to say that white is exalted and pure, green is exuberant, red suggests love or shame or strength. Without the color or its equivalent, life to me would be dark, barren, a vast blackness.
>
> Thus, through an inner law of completeness my thoughts are not permitted to remain colorless. It strains my mind to separate color and sound from objects. Since my education began I have always had things described to me with their colors and sounds, by one with keen senses and a fine feeling for the significant. Therefore, I habitually think of things as colored and resonate. Habit accounts for part. The soul sense accounts for another part. The brain with its five-sensed construction asserts its right and accounts for the rest. Inclusive of all, the unity of the world demands that colors be kept in it whether I have cognizance of it or not. Rather than be shut out, I take part in it by discussing it, happy in the happiness of those near me who gaze at the lovely hues of the sunset or the rainbow.*

Color *is* light, affected by the qualities of surfaces and the workings of our perception. Color *is* evocative, a source for symbols and metaphors. Color is fundamental to human experience.

* Helen Keller, "Analogies in Sense Perception," *The World I Live In* (New York: Century, 1910), Chap. 10, p. 105.

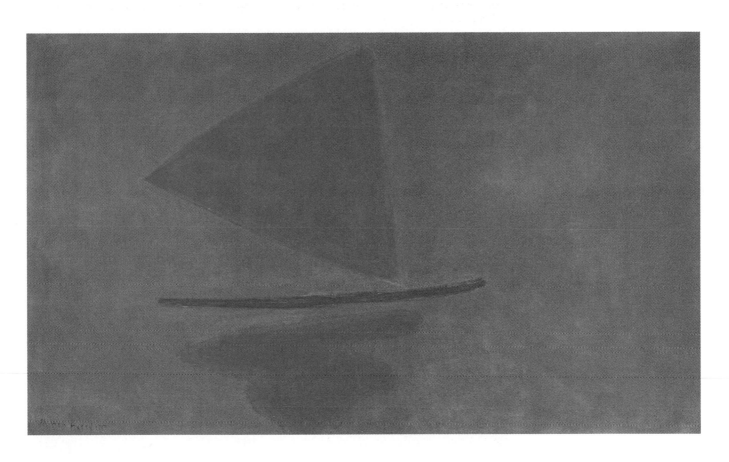

A Milton Avery. *Sailfish in Fog*. 1959. Oil on canvas, 30″ × 50″.
© 2003 Milton Avery Trust/Artists Rights Society (ARS), New York.

The two components of light are **luminosity** and **wavelength**. Luminosity is the degree of brightness of light. The color of the light is defined by the range of wavelengths. Surfaces and media can **refract, reflect, diffract,** or **interfere** with all or selected wavelengths.

We have all seen the effects of light passing through a prism. White light is refracted into the **visible spectrum** (the rainbow sequence of hues) **(A).** Color is a property of light, and the various **hues** are defined by their wavelength. A red object or surface reflects that wavelength of light, absorbing all others. Each leaf in Goldsworthy's collection of leaves **(B)** reflects a limited part of the spectrum. Spectral hues can also be revealed through **interference** and **diffraction** patterns such as those produced by the physical structure of a soap bubble or feather.

The shorter wavelength of blue accounts for the blue sky overhead and the blue hills in a distant view. This shorter wavelength is the predominant one scattered by the atmosphere. The red sun at sunset is the result of shorter wavelengths being dispersed as they pass through a greater distance of atmosphere at this low angle. Only the longer red wavelength survives to meet our eye directly.

There is light beyond the visible spectrum. Infrared is a longer wavelength that exists beyond the red end of the spectrum. Infrared can be rendered visible in "night vision" technology that reveals heat sources. Ultraviolet is a shorter, higher-energy wavelength beyond blue.

Humans and primates are among the few mammals that have color vision. Most other mammals have a more limited experience. Some animals possess a greater range of color perception. Honeybees can see ultraviolet light. Some flowers have patterns that reflect ultraviolet light and attract bees to the source of nectar.

White is the addition of all hues. The white surface of this page reflects wavelengths. Black is the subtraction of all hues. The black ink on this page absorbs all wavelengths.

The visible spectrum is the starting point for understanding how colors mix, interact, and are organized into systems.

A Andrew Davidhazy, *Prism and Spectrum (Prism 01).* Imaging and Photographic Technology, Rochester Institute of Technology.

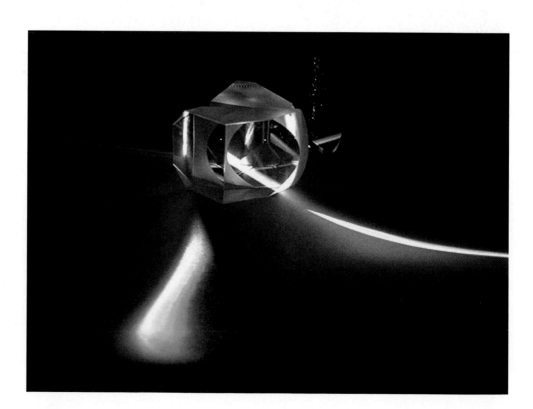

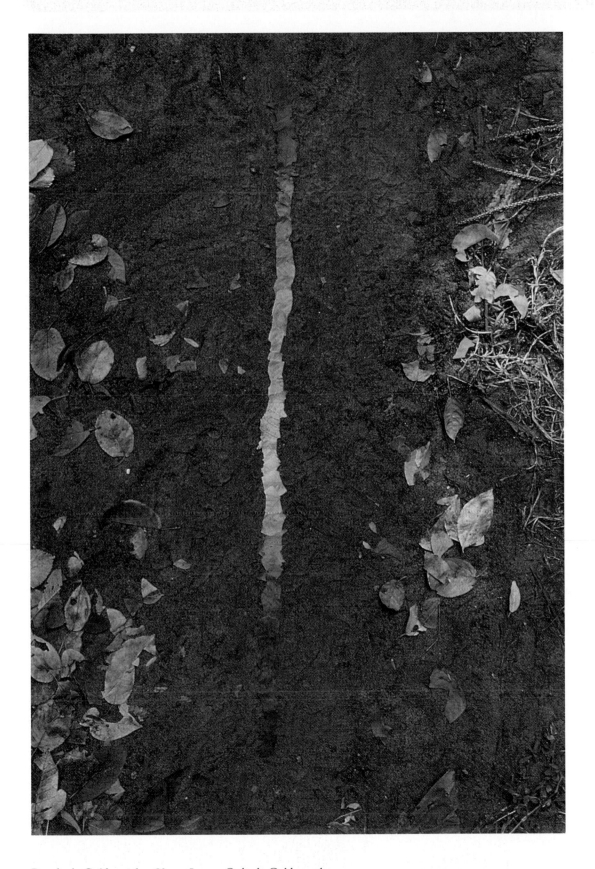

B Andy Goldsworthy. *Cherry Leaves.* © Andy Goldsworthy.

Our perceptual capabilities define our potential for experiencing light and color. Light enters our eye **(A)** through the pupil, which regulates the amount of light, and the lens, which focuses the light. An inverted image is projected onto the **retina,** where an array of **rods** and **cones** are stimulated. These in turn send the image over neural transmitters to the optical region of the brain. The brain, in an act of postretinal correction, reorients the image. The slight disparity (paralax) between the images of our two eyes allows us to experience depth perception.

The cones that make up the color receptors of the retina are sensitive to red, blue, and green. In concert, these are the mixture colors. This three-colored structure forms the **primary colors** of light.

Every stage of the perceptual process influences how we see color, just as varying light conditions affect the color we see. A strong back lighting will cause the pupil to constrict and we will see foreground objects as dark silhouettes drained of color. Under low light the rods will dominate, and our vision will be mostly a range of darks and lights. The periphery of the retina is dominated by light-sensitive rods. When viewing the night sky, we find that we more easily detect faint stars in our peripheral vision.

Prolonged exposure to a color will cause **retinal fatigue:** The color will gradually appear to fade in strength and when we glance away, our vision will be affected by an afterimage. Such afterimages can sometimes linger for an extended period of time.

It is significant that as humans we all see color the same way. While we may not agree on preference, we can count on a commonality of perceptual experiences, such as color matching. People who suffer from color blindness or limited color perception represent the notable exception to this rule. A common form of color blindness is an inability to distinguish between red and green. This is primarily a male genetic disability and can be revealed through tests such as the one shown in **B.**

Most artists may be sensitive to the effects of color but may not consciously consider the workings of the retina as an aspect of their studio work. In areas of design, such conscious application is more likely. Red illumination of dials and gauges in cars or airplanes will not affect the more light-sensitive rods. A driver can see the well-lighted dashboard and not have to adjust for the dark view through the windshield. This design solution assists safe night vision.

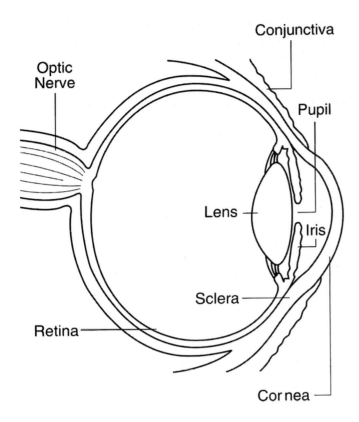

A *The Human Eye.* National Eye Institute, National Institute of Health.

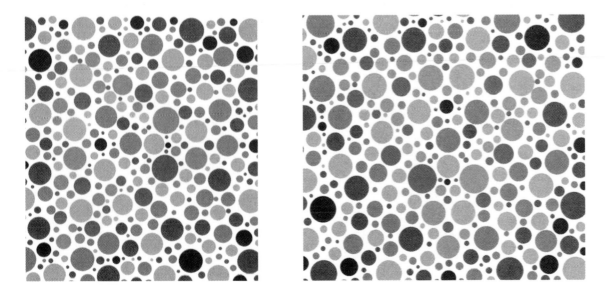

B *Color Blindness Tests.* HRR Pseudoisochromatic Plates. Richmond Products, Inc.

Our attempt to communicate a verbal description of a color experience can easily slip into a vocabulary similar to that of wine tasting. Color descriptions are often subjective and based on associations. For example, even though the hottest part of a flame is blue, colors approaching blue are commonly called cool and those approaching yellow, orange, and red are called warm. This convention of warm and cool colors has more to do with our everyday perception of the sun and the color of sky, ice, and water than any actual reference to the energy associated with a wavelength.

Subjective description is perhaps most evident with the range of ambiguous color names given to paint chips and samples. "Western Reserve Beige," "Bedouin Beige," and "Bar Harbor" **(A)** undoubtedly suggest different colors to different people. While this may be evocative, poetic, or even fun, the names don't communicate much to us unless we are both looking at the same color sample at the same time. Color names based on the attributes of color communicate more accurately the colors and phenomena we observe.

There are three attributes of observed color:

■ **Hue** comes from the rainbow sequence of the visible spectrum, such as red, orange, yellow, and so on.
■ **Value** is the relative lightness or darkness of a color.
■ **Intensity** or **saturation** is the strength or weakness of the hue. A weak hue is almost neutral or grey; a strong hue approaches the intensity of a **spectral hue.**

These attributes are most evident and useful when we are making comparisons. "Bar Harbor" may conjure many possibilities in our imagination, but the sample shown **(A)** can be described as a blue-green (hue) that is dark (value) and moderately intense. The hue is more obvious (and therefore more intense) than in the other two samples, and "Bar Harbor" is darker than the other color chips shown. If you were not satisfied with this color you would be better off describing an alternative by saying, for example, that you would prefer a bluer color, a lighter color, or a more intense color. It would not be very useful to say you prefer "Kennebunkport" over "Bar Harbor."

See also Chapter 2, *Color Systems: Hue, Value, and Intensity Comparisons,* page 26.

A Sherwin-Williams Color Sample (1. Western Reserve Beige; 2. Bedouin Beige; 3. Bar Harbor)
Courtesy of the Sherwin-Williams Company.

Perhaps the most compelling area of inquiry for anyone who deals with color in his or her professional practice is that of color mixture. At the most basic level of observational painting, the question might be "How do I mix that skin tone?" A worker in an auto-body shop might need to mix and match the color of a car that has faded somewhat over the years. A designer may desire to find a dye mixture inspired by the color of a feather. These mixtures, or any that involve dyes or pigments, all fall under the category of subtractive mixing.

Subtractive mixture (A) works like a series of filters and commonly occurs when we mix paint. As a result of this process, any mixture is weaker or darker than the parent hues. For example, red paint plus green paint will yield a dark brown. The red paint reflects only the red area of the spectrum and absorbs other wavelengths while the green paint reflects only the green area of the spectrum. The resultant dark brown mixture suggests that most wavelengths are being absorbed by the mixture.

The mixture problems for a lighting designer or someone adjusting the colors on a computer screen work in an opposite manner. **Additive mixture** principles apply to light **(B).** The sum of all wavelengths of the light primaries (red, blue, and green) gives you white light. Red light plus green light give you yellow light!

A third form of mixture is **partitive mixture (C).** This is a form of **optical mixture** in which the eye will blend small bits of color. An example of partitive mixing can be seen in the photograph of a fence **(D).** Our eye blends the discrete sensations of color reflected off both the foreground and background colors. Red strands weave with the green grass that is visible beyond the fence and push both hues toward yellow. The overall sensation is an olive color that "averages" the two surfaces. This mixture is not darker as might occur with a paint mixture. Neither is it as light as the yellow light mixture since we are seeing reflected light, not a light source.

While these three types of color mixture contrast with each other, they are in fact all aspects of a consistent set of relationships. In each case the color produced is a kind of yellow, the color between red and green in the visible spectrum. The result is lighter and intense with light; median or average with weaving; and darker with paint, dyes, or filters.

See also Chapter 3, *Color in Context: Extended Palette,* page 64.

A Subtractive Mixture

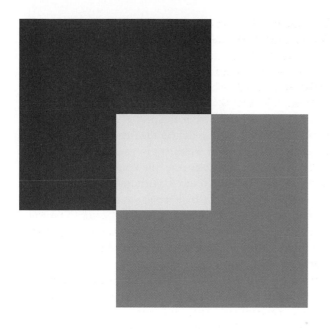

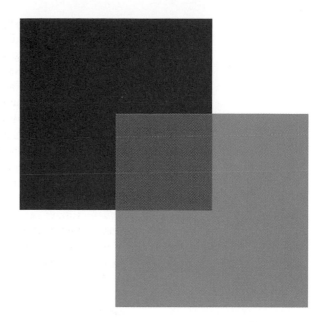

B Additive Mixture

C Partitive Mixture

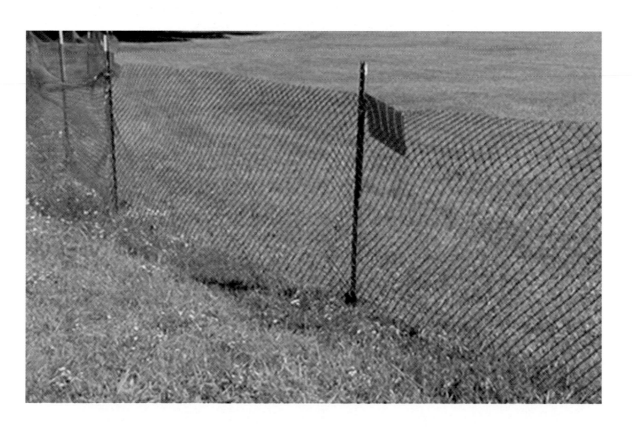

D Mixture effect: green grass appears more yellow through the red fence. Photo courtesy of the authors.

Our response to color is not merely optical or analytical. Color is evocative. It stimulates, inspires, soothes, and agitates. A color may appeal to us or repulse us. Color relationships suggest or alter our reading of spatial relationships. Color forms complex symbolic meanings that can vary dramatically from culture to culture. These powerful evocations motivate art and design. Without this potential to affect human response, any interest in color phenomena would be purely academic.

The Villa of Mysteries at Pompeii, with its Dionysian themes, is dominated by red. Drivers of red cars **(A)** reputedly receive more speeding tickets than those who drive cars of another color. It is no surprise that red is associated with extreme emotions.

Blue tends to recede in a picture relative to other colors. As the landscape recedes into the distance, it takes on the color of the blue sky. Blue tends to withdraw while other hues advance. A grey green that may be appealing in a textile may repulse as a skin tone. Yellow and black warn of danger in the stripes of a wasp **(B)** or in the pattern of caution tape **(C)** at a construction site. White is used for weddings in one culture and funerals in another.

The evocative power of color is both a product of natural phenomena and a learned response. Connotations can be universal or culturally specific. It has even been speculated that a Western, rational, male view of the world is challenged by color, with its associations with femininity, intuition, and "other" cultures. Color has the potential to elevate or subvert, to reveal or veil in obscurity.

See also Chapter 6, *Color in Nature and Culture: Warning and Display,* page 148.

C Caution Tape

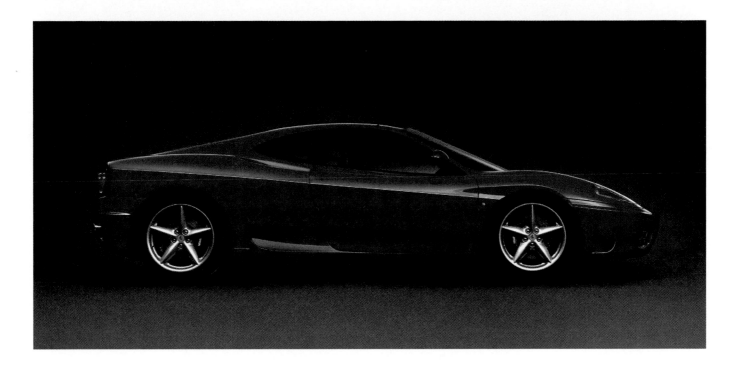

A *Ferrari Modena.* Courtesy of Ferrari North America, Inc.

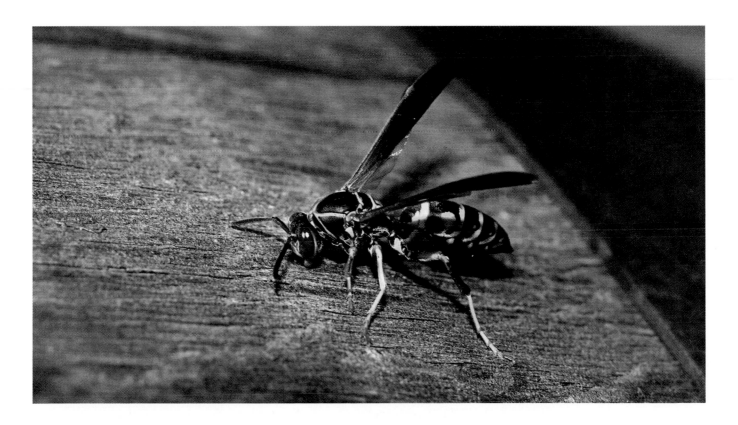

B Warning colors of black and yellow on a wasp. © Royalty-Free/CORBIS.

Context has a profound influence on how we see and what we know. Monet's cathedral paintings (**A** and **B**) show a vastly different color description of the cathedral bathed in afternoon light (**A**) and in morning shadow (**B**). The variable nature of light exerts one level of change.

Our reading of a color is also affected by memory and expectation. Although our eyes may see the cathedral change color over the course of the day, we may still describe the building as grey based on a preconception for the color of stone. This phenomenon is called the **constancy effect.** The constancy effect is a useful adaptation for daily life because it allows us to function without doubt or distraction, but it dulls us to the actual changes around us. Monet sets an example for artists to move beyond this less-conscious level of daily existence.

In the film *True Stories,* David Byrne tells us that we notice the differences when we travel to a new place—the shape of an architectural detail or the color of white paper. Gradually things become familiar, and we no longer notice these things.

How we identify a color is further affected by the nature of the surrounding environment. Seen in isolation, denim may appear to be very blue—*if* there are no other blues around. Denim blue may look much more drab in contrast to the intense blue in a tropical shirt. The denim has not changed, but the context has.

This very flexibility of how we see color challenges fixed notions for what a color is, should be, or should mean. How can we say that a color has a fixed meaning when that color is subjected to manipulation by context?

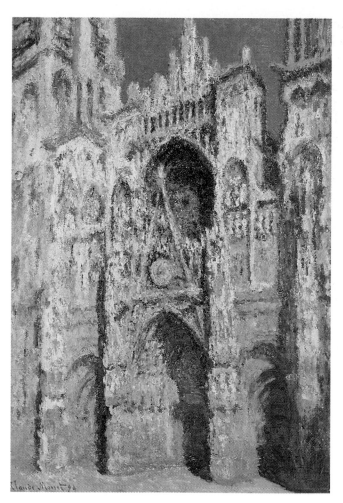

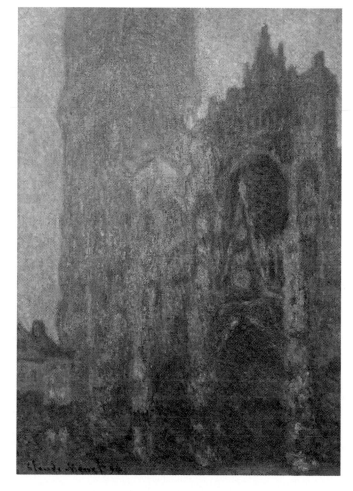

COLOR WHEEL

Color systems have been developed over the years out of a human curiosity and a desire to clearly communicate color relationships and interactions. The simplest and certainly best known structure for explaining color relationships is the color wheel. This circle is created by closing the ends of the visible spectrum into a circle of hues. This forms the basis for more elaborate systems as well.

Isaac Newton proposed the first such model in the eighteenth century **(A).** His wheel was among his contributions to our understanding of the physical world based on observation. This sequence of hues forms the basis for all color wheels developed since then. The various color wheels have similarities but also some important differences, such as the number of steps and the degree of each step. Refinements over the basic color wheel have attempted to explain the relationships between the hues by identifying key colors.

Some color wheels identify primary colors: hues that form the basis for mixtures and cannot themselves be arrived at by mixture colors. Hues that lie opposite each other are also significant; these are known as **complementary colors.** This is more than an arbitrary placement. Complements neutralize each other in mixture and accentuate each other in juxtaposition.

Johannes Itten was a painter and teacher at the **Bauhaus** in Germany in the 1920s. The Itten color wheel **(B)** is a familiar model that identifies red, blue, and yellow as primary colors. The mixtures of these primaries produce the **secondary colors**—orange, violet, and green. The Itten color wheel is satisfying in the symmetry of its relationships. Primaries form an equilateral triangle similar to Johann Wolfgang von Goethe's earlier color triangle **(C).**

The Itten model has shortcomings, however. The hues are not equal visual steps, and magenta is left as a mixture color between violet and red and is not shown in illustration **B.** This model is imperfect in predicting mixtures as well. Yellow light plus blue light produce white light. Yellow paint plus blue paint produce a very low-intensity green.

Color wheels based on the primaries of light or pigments prove to be more useful, as are models that are based on equal visual steps. Such models prove to be more consistent in the color mixtures and interactions they predict.

A Newton's Color Wheel from *Newton,* 1704, Book I, Part II, Plate III.

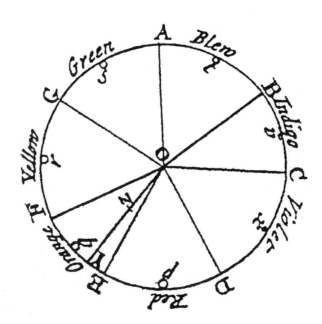

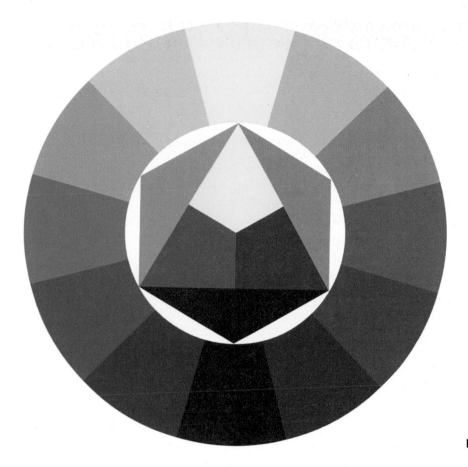

B Itten Color Wheel

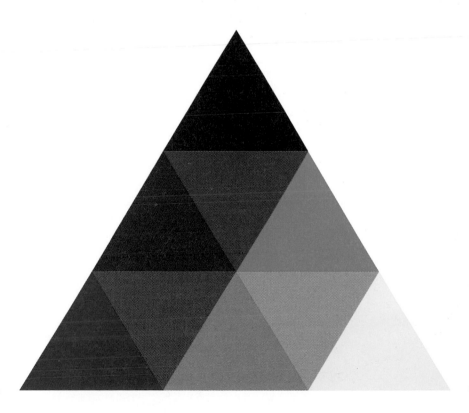

C Goethe's Color Triangle

PRIMARY COLORS

Primary colors are the hues that are essential to the mixture of all other colors. The primaries for light mixture are red, blue, and green. These are called **additive primaries,** and together they mix to produce white light. The human eye's receptors are sensitive to these three hues. Mixture pairs of red, blue, and green light **(A)** create the following colors:

Red plus blue create magenta.
Blue plus green create cyan.
Green plus red create yellow.

This form of color mixture is seen most commonly on a television or computer screen.

The primaries of pigment or dye mixtures are called **subtractive primaries.** These are the secondary colors of light mixture: cyan, yellow, and magenta.

Magenta plus yellow create red.
Cyan plus magenta create blue.
Yellow plus cyan create green.

These primaries are more accurate than the ubiquitous red, yellow, and blue, which yield duller mixtures. A mixture of the three subtractive primaries approaches black **(B).** Commercial offset printing, the process used to produce this book, is a common application of the subtractive primaries. Black ink is used in printing for greater contrast. Since all subtractive mixtures result in a loss of intensity, additional hues are often used in painting or printing.

The mixture diagrams **A** and **B** also show the complementary colors. For example, cyan is opposite from red. Cyan plus red create white light. Cyan paint plus red paint create black. Whether an additive mixture for light or subtractive for paint, in both cases the mixture is neutral. Both **A** and **B** show hues in the same order and the same sequence as the Itten or Newton color wheels.

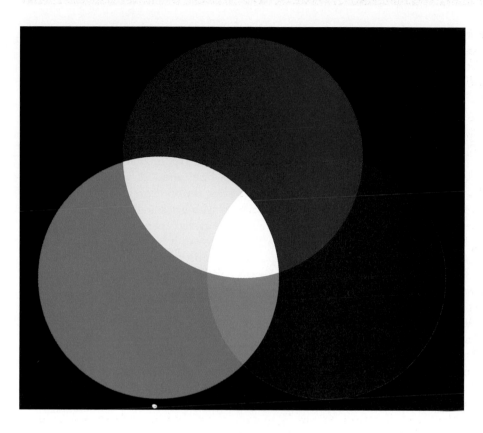

A Additive Primaries. The circles suggest overlapping cones of light.

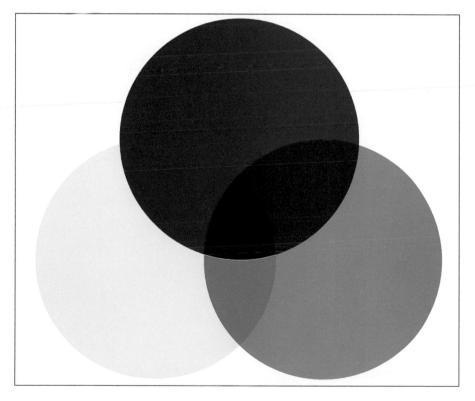

B Subtractive Primaries. The circles suggest overlapping films or filters.

GREY SCALE AND MIDDLE GREY

Value is the lightness or darkness of a color. While this is a relatively simple concept, in practice it can be more complex.

The most obvious expression of value is a grey scale from white to black **(A).** Extreme white and black are conditions of light or total darkness and cannot be reproduced in print. The human eye can perceive hundreds of value steps between these endpoints. The visual halfway point between black and white is middle grey. This is the same value as a photographer's "grey card." This grey card works as an average surface in terms of reflected light. The standard for a "grey card" is 18% reflective. A middle grey mixture of paint is also not a 50/50 proposition: The proportion is closer to 25% black and 75% white.

One way of determining middle grey is by observing the border relationship with black and white. If the grey has equally contrasting borders with black and white, then it is middle grey **(B).** This is a judgment that can be made and agreed upon, but middle grey is not something you can commit to memory. For the human eye it is always a judgment made in context, a best choice among several options. There is no such thing as precise color memory or the visual equivalent of musical perfect pitch. Our perception of value interval depends on border relationship. The degree of contrast for two values is more difficult to judge when the samples are isolated.

Grey values can also be produced through an optical mixture of small black and white bits or marks. The greys on this page are produced in this manner and can be detected with a magnifying glass. This dot pattern is more obvious in a newspaper photograph.

In two-dimensional art and design, emphasis can be created through strong contrast **(C)** or subtle gradation of value **(D).**

A Grey Scale

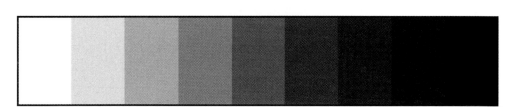

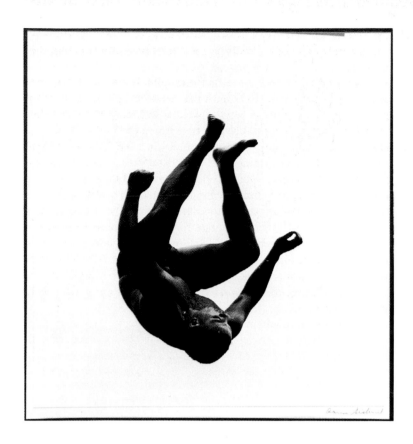

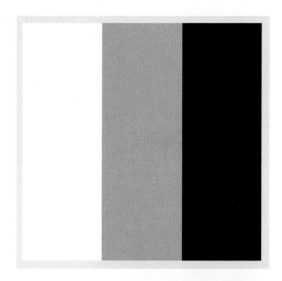

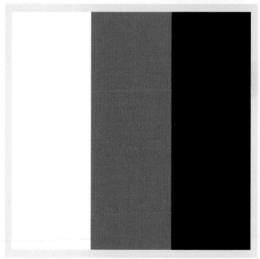

C Aaron Siskind. *Terrors and Pleasures of Levitation, No. 474.* 1954. Gelatin silver print, 1972, 25.4 × 24.2 cm. George Eastman House.

D Jan Groover. Untitled (American, 1943). Gelatin silver print, sepia-toned, Sheet: 40.6 × 50.7 cm; Image: 30.3 × 39.5 cm. 1986. Purchased with a grant from NEA and matched by contributions from museum members in 1989. Inscription: written in pencil on recto: "305.3 2/25"

B Evaluating Middle Grey

INHERENT VALUE

Value is more complicated as an aspect of color. Every color we perceive has a value, and this value can be matched to a grey scale. Colors can vary in value with the amount of white and black we perceive in them. These are called **tints** and **shades** of colors. The human eye also perceives pure hues as having different values as well. This is called **inherent value.** This is most obvious in the contrast between yellow and blue. The human eye perceives yellow as lighter and blue as darker **(A).** Other hues fall between these extremes.

Other value relationships may be less obvious. For example, is a red lighter or darker than a green? The value of a hue can be determined by comparison with a grey scale. Is the color lighter or darker than the adjacent grey? We can only make this judgment with greatest confidence by trial and error, and we can confirm that judgment only when the borders are touching. When the grey and the hue are the same value, the border will tend to melt. When the hue is intense, the border will tend to vibrate for middle values. Recognizing the value of a color is important in creating emphasis in a composition. The inherent value relationship in **B** effectively creates emphasis by contrast.

The Navajo rug shown in **C** consists of black, white, and indigo. The indigo is a pure vat dye without any black added. The border between black and indigo melts away while the white stands in strong contrast to both.

A *Inherent Value,* 5 ed. from David A. Lauer and Stephen Pentak, *Design Basics* (Fort Worth: Harcourt Brace & Company, 2000), 236A.

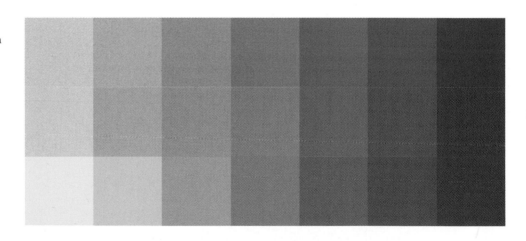

B *Lufthansa* ©AFP/CORBIS.

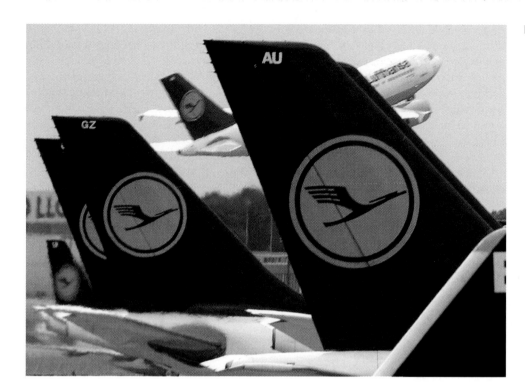

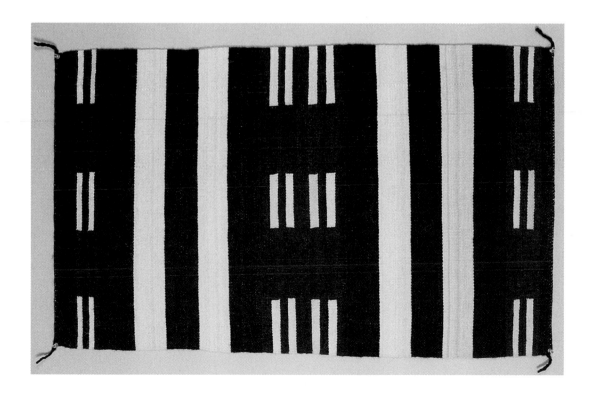

C D.Y. Begay, *First Phase Chief Style, Navajo Rug*. Photo by Howie Meyer.

Any color we observe has a hue and value associated with it, and it also has one other attribute we can see: **intensity.** Intensity is the saturation of hue. This can be thought of as a degree of distance from a neutral grey. Color systems based on human observation will include intensity as one dimension independent from value (lightness or darkness).

When only the intensity of a color is changed, it is easier to see that intensity as a distinct quality apart from value or hue. The color scale shown in **A** forms a gradation from a grey to an intense orange (or red-yellow). The hue remains consistent. It does not vary toward yellow or red. The value remains constant. The color samples do not become lighter or darker. Only the intensity is varied.

The colors shown in **B** resemble those in **A.** They all are variations on an orange hue just as they are in the first scale. The samples for **B** *do not* come from sources we commonly think of as "orange" (or red-yellow.) From left to right, the samples are:

A paper bag
Blonde hair shown in *Vogue* magazine
Bread crust
African-American skin tone shown in *Vogue* magazine

We may customarily call these colors brown, blonde, tan, or sepia, but in this context we can see they are all different intensities of an orange hue.

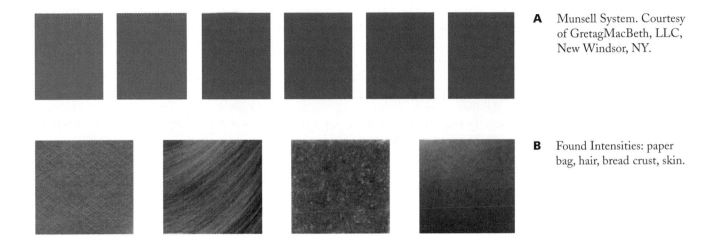

A Munsell System. Courtesy of GretagMacBeth, LLC, New Windsor, NY.

B Found Intensities: paper bag, hair, bread crust, skin.

Hue, value, and intensity are seminal color terms. The comprehension of many other concepts hinges on a working knowledge of hue, value, and intensity. To make sure you really understand these three important color attributes, answer the following questions.

QUESTIONS

Value: Select the lightest color from each color pair in illustrations **A, B,** and **C.**

Hue: Identify all six hues in illustrations **D, E,** and **F.**

Intensity: Select the most intense color from the color pairs in illustrations **G, H,** and **I.**

ANSWERS

A *When we ask about value, we don't care if the color is red or green, intense or dull. We just want to know if a color is lighter or darker than its neighbor. The yellow-green on the left is lighter. It is fairly easy to judge value when colors are the same hue.*

B *The yellow-orange on the right is slightly lighter.*

C *The cyan blue on the left is slightly lighter. When colors are close in value, intense, and of different hue, determining the lightest becomes extremely difficult.*

D *Both colors are the same hue—yellow. On the left is a pure yellow, and on the right is a shade of yellow.*

E *The left hue is red and the right is yellow-orange.*

F *The left hue is red and the right is without hue. It is neutral—grey.*

G *The yellow-orange on the left is more intense than its tint on the right.*

H *The blue on the left is more intense than the red-orange on the right.*

I *The blue on the right is slightly darker than the yellow-green on the left but they are similar in intensity.*

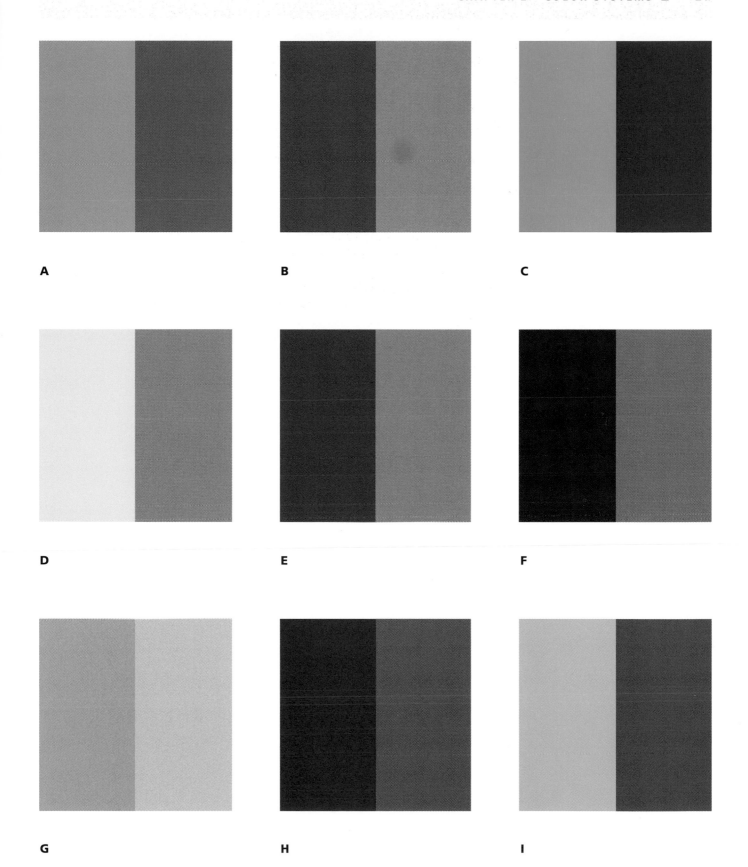

A

B

C

D

E

F

G

H

I

Our perception of color can be described through three qualities: hue, value, and intensity. These three attributes suggest that any two-dimensional model (such as the color wheel alone) would not be complete as a color system. A collection of surface colors that would accommodate any color chip or sample would have to be a three-dimensional model. Such an organization would put every color sample in a consistent relationship to every other sample. This would allow us to move from any one color to another through steps of hue, value, and intensity.

The simplest way to describe such a system would begin with the color wheel describing the equator of a color sphere. An axis through that sphere would be a value scale (grey scale) with white at the north pole and black at the south pole. Moving outward from this grey scale axis toward the surface of the sphere would give us the intensity dimension. Neutral greys would be at the core, with more intense saturations of hue toward the surface.

A color sphere designed by Philip Otto Runge in 1810 is shown in **A.** This model is based on paint (subtractive) mixtures. The two top views show the sphere from the outside (the lighter and darker hemispheres). The two bottom illustrations show cross sections through the sphere. On the left is a slice at the latitude of the equator with the twelve-step color wheel at the outer edge. On the right is a vertical cross section.

This early model by Runge sets a pattern for subsequent refinements. It may have been limited by available pigments, but the pattern is consistent with systems that would follow. That pattern includes:

> Primary colors (red, yellow, and blue)
> Secondary colors (orange, green, and violet)
> **Tertiary colors** (half steps between the secondary colors)
> Complementary colors (opposite on the wheel and neutralizing in mixture)

Later systems would refine and elaborate on the role of primary and complementary colors.

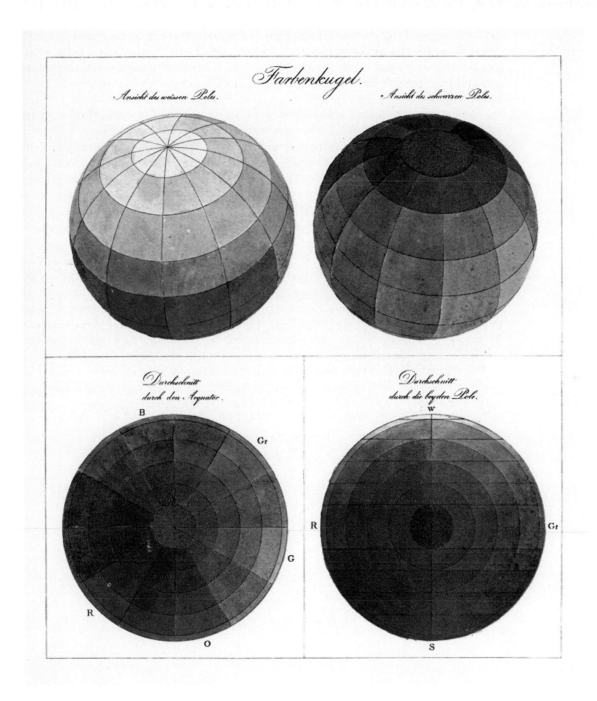

A Philip Otto Runge: Color Sphere from Runge, *Die Farbenkugel,* Hamburg, 1810.

Wilhelm Ostwald developed a color system in the early twentieth century that is three-dimensional and is a refinement on the Runge model. The Ostwald System is based on four primary colors and a color wheel with 24 steps. The addition of sea green to red, yellow, and blue provided for more intense hues and a 24-step color wheel with more equal visual steps **(A)**.

The Ostwald System is a double cone rather than a sphere. The color wheel is at the equator and the core is a neutral value scale with white at the top and black at the bottom. Colors on the surface of this double cone are pure hues at the color wheel with **tints** (the hue plus white) moving toward the white point and **shades** (the hue plus black) moving toward the black point. Ostwald called these tints and shades "clear colors" as distinguished from the range of intensities that appear to have a degree of grey in their appearance. A section of this model can be seen in **(B)**.

One characteristic of the Ostwald System is the symmetry of the model. This symmetry appeals to a sense of harmony or balance that is often desired in design. The symmetry of the system has one drawback, however: it is a closed system. If more intense dyes or pigments are discovered, the system cannot accommodate their addition without disrupting the symmetry. In fact higher intensity cyan and magentas are not included.

The symmetry of this system also results in unequal visual steps. This system has the same number of steps from blue to white as it has for yellow to white. However, yellow is inherently lighter than blue and the steps from yellow to white are more subtle than the pronounced steps from blue to white.

The Ostwald System provides an interesting model for subtractive color mixing and gradations of color can be plotted in a variety of paths moving through the three dimensions. The system is not as useful as a reference for color identification.

B Ostwald Intensities. Courtesy of the Ostwald Institute. www.wilhelm-ostwald.de

A Ostwald Color Wheel. Courtesy of the Ostwald Institute. www.wilhelm-ostwald.de

The color system of Albert Munsell, first developed in the early twentieth century as an aid to teaching, is still in use today. Unlike the Ostwald System, the Munsell model is an open system and has been refined over the years.

The Munsell System is similar in construction to earlier models with a value scale at the core, hues arranged in a color circle around this core, and intensities progressing outward from the core to the pure hues. The significant advancement of the Munsell System is an open-ended structure that allows for the addition of more intense hue steps as they are discovered.

Munsell based his system on a principle of equal visual steps. It is a system devoted to observation of color surfaces, not paint mixtures. The color circle is based on ten evenly spaced hues, and primary colors are not significant or identified as such. A total of one hundred hues are identified including the ten basic divisions.

Value is accounted for by a ten-step scale. **Inherent value** is accounted for in the Munsell model. A pure yellow is placed at the level of a light value. A pure blue is placed at a darker value. The color wheel of pure hues does not fall along an equator as with earlier systems. These purest hues occur at their inherent value and this gives the system an asymmetrical outer form.

Munsell gives the dimension of intensity the term **chroma.** Chroma steps are steps from neutral to a pure or saturated hue. The human eye will read different degrees of chroma for different hues, and as dyes or pigments are developed the system allows for increased levels of chroma if they are found. The different range of intensities for various hues also contributes to the asymmetry of this system **(A).** A sample section for a single hue can be seen in **B.**

The Munsell System is a useful reference for communicating specific color observations. Coca-Cola Red may mean different things to different people. A red at Hue 5R, Value 4, and Chroma 12 will specify a distinct red. Certain paint manufacturers will identify their colors with Munsell information.

Complementary colors can be confirmed by an afterimage test. If a hue is viewed for an extended time, an afterimage of the complement will appear on a neutral surface for the viewer. This afterimage color is consistent with additive and subtractive mixing principles: that is, the complements will neutralize in mixture.

See also: Chapter 3, *Color in Context: Afterimage,* page 40.

A Munsell Color System. The Color Tree. Courtesy of GretagMacBeth, LLC, New Windsor, NY.

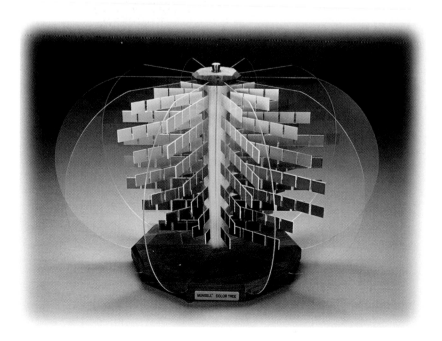

Munsell Color Order System

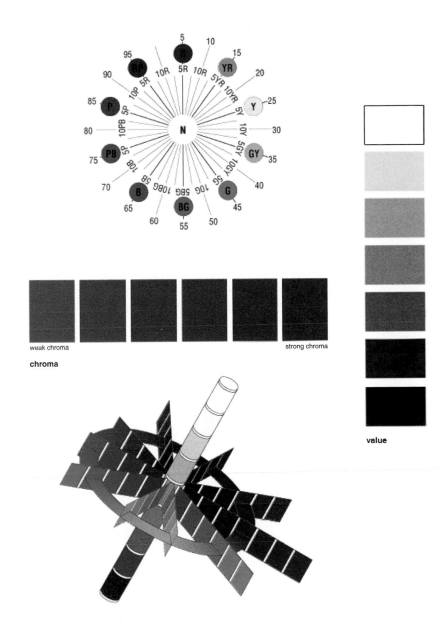

weak chroma strong chroma

chroma

value

B Section from Munsell System, Munsell Chroma. Courtesy of GretagMacBeth, LLC, New Windsor, NY.

The CIE System (*Commission Internationale De L'Eclairage*, or International Commission on Illumination) was developed as a reference for comparison of light sources and is in use today. This system is based on the primaries of light: the three-colored or **tri-chromatic** basis of human perception. The graph that illustrates this system shows two dimensions of these three variables **(A)**. Thus the white light point that would be a mixture of red plus green plus blue is at a point .33 red (*X* axis) and .33 green (*Y* axis). The third component of .33 blue (or the *Z* axis) is implied. Yellow is shown to be 50% red, 50% green, with no blue component.

The purple region of the color wheel is shown here along a mixture line between red and violet. Complementary relationships exist between hues opposite each other on a line through the white point.

The graph reveals the chromaticity (or color of light) plotted by the proportion of wavelengths (measured in nanometers). Luminosity (or strength) of light, which is measured in lumens, is not a variable.

This system is valuable for showing the color shift for different light sources. Daylight at noon is closest to the white point. At sunrise the light shifts dramatically toward red. Different artificial light sources can be plotted for their color bias. Incandescent is biased toward yellow. Objects that appear blue under noontime daylight will look less intense under incandescent light.

The CIE System is based on the physics of color spectrometry, but is keyed to the tri-stimulus (red, blue, and green) sensitivity of the human eye. It is an accurate reference for light sources, but is not as useful as the Munsell System for comparison of surface colors.

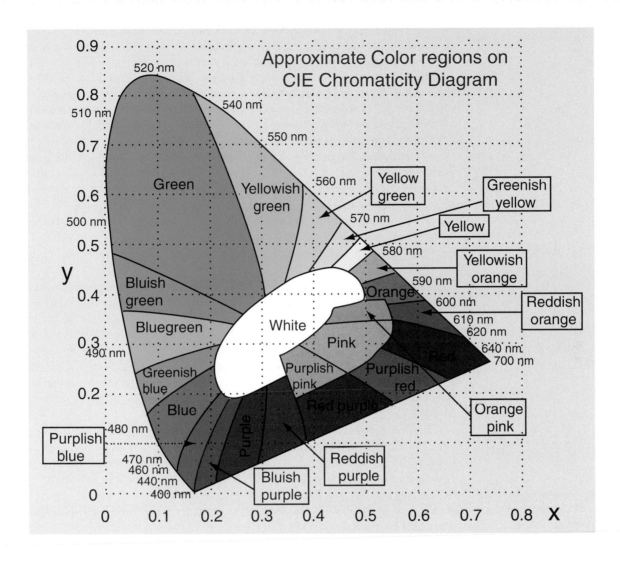

A CIE System. Courtesy of Carl R. Nave, Georgia State University.

Fundamental and theoretical models such as Ostwald, Munsell, and CIE explain color relationships and provide references for communication. They form the basis for catalogues or systems designed for specific practical applications.

One such widely used resource is Pantone. This company provides color reference guides that allow color matching for a four color CMYK (cyan, magenta, yellow, and black) printing process **(A).** This is a subtractive system based on **translucent** inks: a mix of cyan and yellow will produce a green, for example. Guides are also available for a six-color process that allows for a greater range of intense mixtures. A translation of such colors to a red, blue, and green additive system such as used in computer-based applications is also available.

However, the most popular color reference system from Pantone provides choice for spot color matching (custom inks) when a mixture color is inadequate. Additional guides provide translation of the spot colors to a red, blue, and green additive system such as used in computer-based applications, as well as the ability to match a spot color to its closest four-color mixture. Color reference tools are also available to support the special needs of the textiles and plastics industries.

A second widely used reference is the 216 color chart of Web-safe colors, or colors that are within the limits of a computer that is set for 256 colors. These colors are each given a red, green, and blue component from 0 to 255. This is a standard scale for color mixing on the computer. White is 255R, 255G, 255B and black is 0R, 0G, 0B. Red is 255R, 0G, 0B and blue is 0R, 0G, 255B. All the mixtures would be arrived at through various levels of red, green, and blue. The Web-safe colors are 216 steps from these possibilities **(B).** The 216 colors are based on a scale from 0% to 100% in five equal (20%) steps for each primary hue. On this chart an example of a light grey is 204R, 204G, 204B. A red orange would be 100% red (255R), 20% green (102G), and 0% blue.

The Web-safe palette is no longer necessary for most computers, but it provides a good example of simple additive mixtures in a light-based system. The preceding systems ensure predictability in printing processes and translations from one media to another. In practice any media runs up against limits: CMYK printing process will be limited to "gamut colors": a range within the broader range you can see on your computer screen. The complexity and versatility of any medium or system is best understood through specific practice. The general principles that connect all of these systems are consistent:

The sequence of hues (the color wheel) is the same whether or not primary colors (additive or subtractive) are identified.

The eye perceives color relationships with three components: hue, value, and intensity.

Complementary colors neutralize each other in mixture and are confirmed by afterimage effect.

Recognition of these underlying fundamentals makes it possible to acclimate to a variety of charts or systems for practical use.

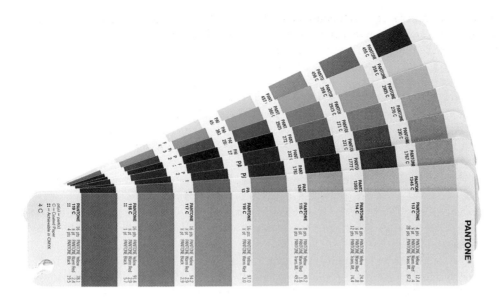

A Pantone color chart. Courtesy of Pantone.

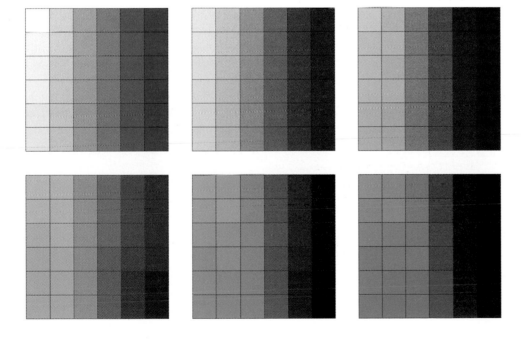

B Netscape Web-Safe Palette. Courtesy of Gary W. Priester.

An awareness of the contextual influences on observation is an attribute of modernity and contemporary life. The world seems divided between those who view things as black or white and those who acknowledge shades of grey. An absolutist view seems to be a leftover from medieval times. The field of quantum mechanics tells us that our mere observation changes what we observe.

Josef Albers, a prominent twentieth-century painter and teacher, advised his students to "see in situations." He encouraged his students to see more than facts; he wanted them to see what was actually occurring in front of them. The grey strip shown in **A** is in fact only a middle grey, yet it appears to be a gradation from dark to light. The changing values of the areas bordering the strip create a change in situation for how we see the strip. This middle grey appears darker in contrast to a light surrounding and lighter in contrast to a dark surrounding.

Is this merely a trick? An optical illusion similar to a magician's sleight of hand? This question was put to a class of young high school students. The quick response was "Yes." After a number of students supported that conclusion, one student offered a different view. She observed that this was no more an illusion than any of our daily observations, which are affected by the context in which they occur. A quiet wave of understanding swept through that class.

While an awareness of the relativity of perception may seem modern, this level of awareness is seen in earlier times in artworks and color investigations. Nineteenth-century painter Eugene Delacroix is reputed to have said, "Give me mud and I will give you a skin tone if I can control the colors around it." In the same time period, chemist Michel Eugene Chevreul published his observations on color perception. Significantly, he noted that while the dyes used in woven tapestries were one factor in the range of possible colors, the influence and effect of these colors on each other was important. How colors appeared side-by-side, the amount of each color, and the repetition were most critical.

In the twentieth century it was Albers who brought the keenest attention to contextual color, as seen through his teaching and his own paintings. The examples shown in this text are based on those studies but will show examples from art, design, and the environment beyond the studio investigations many students have done with colored papers or paint.

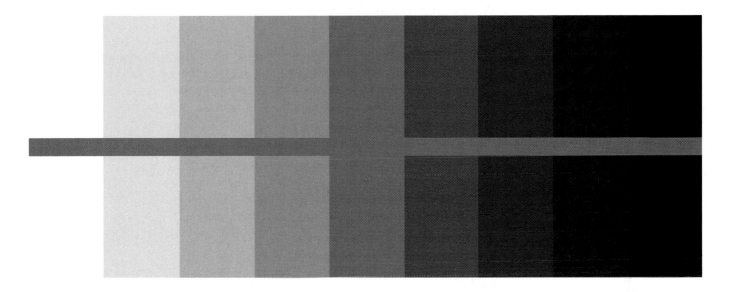

A A middle grey strip appears to gradate in contrast with the grey scale.

An essential component to understanding how colors interact is the phenomenon of **optical afterimage.** This afterimage effect happens in obvious and dramatic ways when we stare too long at a saturated hue, and it happens on a subtle level in more ordinary situations.

If you hold your vision on the yellow circle **(A)** for an extended time, you will find that the color seems to bleach or fade, and it is difficult to continue gazing at it. Focus on the center dot and continue to do so for a half minute. Then glance quickly at the light grey circle on the right. A blue-purple circle will appear and linger for a moment. This afterimage is a result of retinal fatigue. Those receptors sensitive to the complementary color will now see that hue in the white area while the receptors sensitive to yellow will not register that component in the white area.

This effect will happen around every color to a lesser degree. The grey of a tree trunk may take on a violet quality in contrast to the yellow-green foliage. As Vincent Van Gogh observed, the shadow of a lemon looks blue next to the yellow fruit.

This afterimage effect can be seen along the border between a grey and two complementary colors, as in **B.** The grey will take on a yellow complexion along its border with the blue-purple. It will also take on the blue-purple hue along its border with the yellow. Stare at the center of the grey stripe, and the complementary colors will bleed from these edges.

This influence of a color on its neighbor is ubiquitous. To a greater or lesser degree, every color is influenced by the color we see adjacent to it.

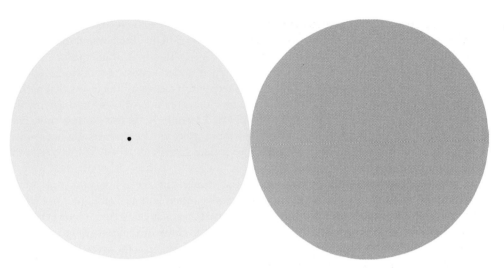

A Yellow Circle

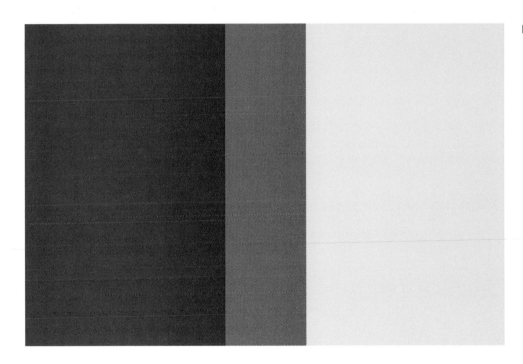

B Complements with Middle Grey

Simultaneous contrast is the most vivid example of how our perception of a color is affected by the surrounding environment. The effect of two different backgrounds on the same color sample is most obvious when seen simultaneously in a side-by-side comparison **(A).**

The autumn leaves are identical and photographed under a consistent diffused light. It is only the effect of the surrounding color that alters our perception. The leaves that appear brown (yellow) against the grey pavement take on a magenta hue when viewed against the green lawn. This contrast is presented in a simplified form in **B.** In this context three colors appear to be four. The change in the small color samples will be most pronounced when viewed simultaneously (with both samples in your field of vision). It will be less obvious if you scan back and forth from left to right.

The changes we observe can be described in the simple language of hue, value, and intensity. In the new environment, has the color apparently shifted in hue? Is it lighter or darker? Is it now more or less intense? All three of these attributes may be altered in our new view of the color. A simple way to understand this effect is to think of the background subtracting its identity from the foreground color. In this particular example, the green lawn subtracts its hue from the leaves, pushing their color toward the complement of green–magenta.

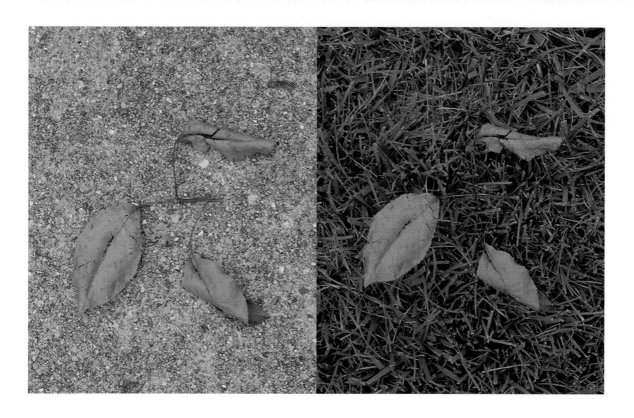

A Leaves on Two Grounds

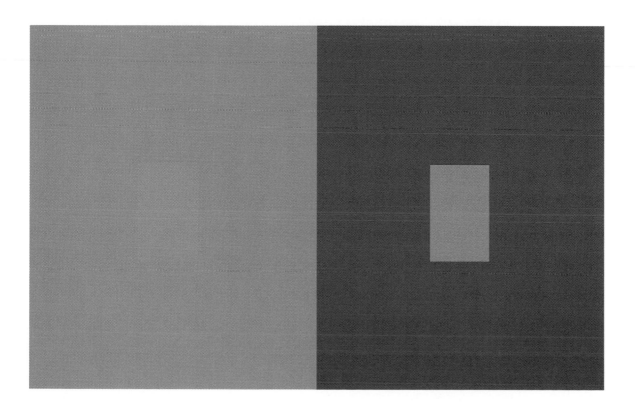

B Simplified Version

We seldom see the phenomenon of simultaneous contrast presented like a graphic illustration in daily life, but in actuality it occurs in every moment of perception. Merely changing your point of view by a few inches or viewing the same object against a split background will usually reveal such a change in color perception.

Johannes Vermeer's painting *Girl with the Red Hat* (**A**) shows just such an observation. Illustration **B** shows that the lion's head chair post on the left looks lighter and takes on a red hue against the dark background. The post on the right is framed by the light hand and a line of white highlights. It looks darker and greener than the post on the left. The dark blue-green backdrop subtracts out this quality from the ambiguous brown chair post, pushing it toward a lighter red (opposite of the background). The lighter situation around the right post subtracts out the lighter quality of the post, pushing it darker and (by contrast to the left post) greener. In this case, Vermeer made this contrast explicit by painting the change he saw.

This color change could occur by placing an identical olive or brown against two different grounds, as in **C**. However, Vermeer heightened the sensation in the painting. We do not question that the chair is consistent, but we recognize that the context altered the appearance.

B Johannes Vermeer. *Girl with the Red Hat* (Detail). c. 1665/1666. Oil on panel, Andrew W. Mellon Collection. Image © 2003 Board of Trustees. National Gallery of Art, Washington.

C Three colors become four.

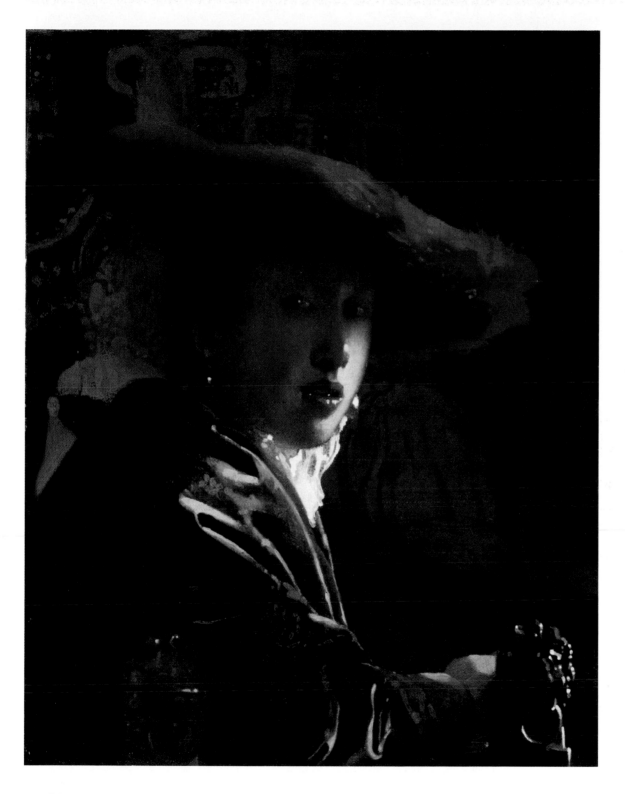

A Johannes Vermeer. *Girl with the Red Hat*. c. 1665/1666. Oil on panel, Andrew W. Mellon Collection. Image © 2003 Board of Trustees. National Gallery of Art, Washington.

In the previous examples, a color changes its identity against two different backgrounds. In this situation, three colors appear to be four. Thus, we can say that the result has become *more* than the three colors presented.

The effect of simultaneous contrast can also create a situation in which the result appears to be *less*. Two fragments from Jean-Baptiste-Siméon Chardin's still-life painting in illustration **A,** *A "Lean Diet" with Cooking Utensils,* are examples of how a mixture color can change its identity. Three colors can effectively become two when the sample or foreground color is the middle color between the two background colors. In **B** the shadow line on the copper kettle looks like the olive background. The orange-red streak on the olive-colored spoon reflects the copper kettle. In fact, both streaks are (in some areas) the same color—the middle mixture between the "copper" and "olive" as shown in simplified form in **C.**

Illustration **C** demonstrates three colors becoming two. The horizontal strip takes on the identity of the opposite background. The color of the strip is in fact constant, as shown below the illustration.

This interaction is one of many taking place in the Chardin painting. The picture is composed of a simple palette of few colors yet offers a complex set of changing border contrasts.

B Jean-Baptiste-Siméon Chardin. *A "Lean Diet" with Cooking Utensils* (detail). 1731. Oil on canvas, 13″ × 16¼″. Musee du Louvre, Paris. Copyright Erich Lessing/Art Resource, NY.

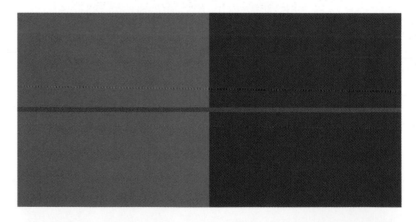

C Three colors become two.

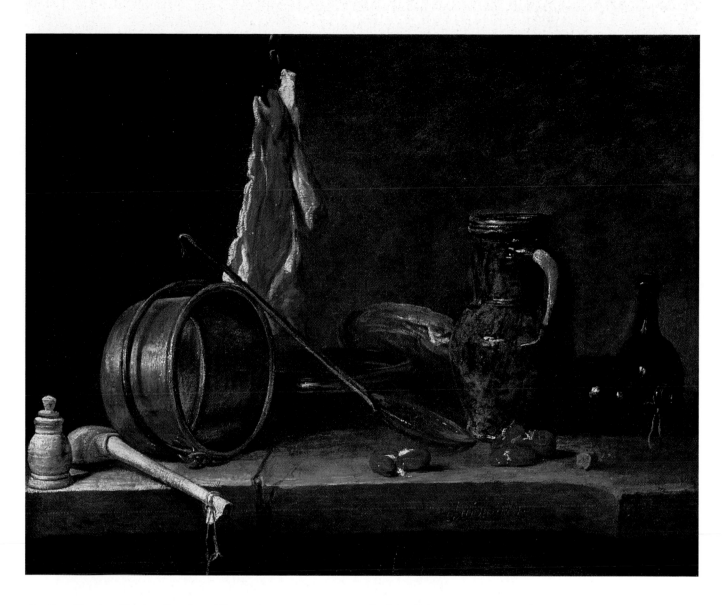

A Jean-Baptiste-Siméon Chardin. *A "Lean Diet" with Cooking Utensils.* 1731. Oil on canvas, 13″ × 16¼″. Musee du Louvre, Paris.
Copyright Erich Lessing/Art Resource, NY.

Chardin's painting *Lean Diet* could be a study for a variety of color interactions. The apparently straightforward palette of few hues gives the appearance of simplicity. However, the composition has many complex relationships. The red meat sits in the background, but the red is repeated in the foreground. This dual role exists for almost every color and hue.

Among the many repetitions of shape, color, and value, some repetitions are in fact varied in color. The shadow on the pepper mill at the left margin resembles the color of the background on the right side of the painting **(A).** This echo provides a connection between the two sides of the painting.

In fact, these two areas are different in value: It is their surroundings that push them to appear alike. The lighter surroundings for the left-hand sample subtracts out this quality, pushing the shadow color darker. Conversely, the frame of darkness on the right pushes the middle value lighter in appearance **(B).**

This is demonstrated in simplified form in **C.** Two different colors look alike in this context. The color samples shown below **C** reveal their difference. The background colors subtract out the difference between the samples, pushing their appearance toward a color midway between the two. Notice that the color area of the samples is surprisingly large in relationship to the background and that the change exerted by the backgrounds is rather dramatic.

C Two different colors look similar: four colors become three.

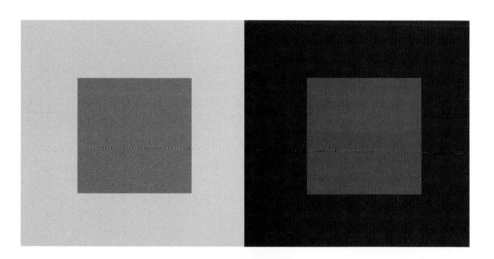

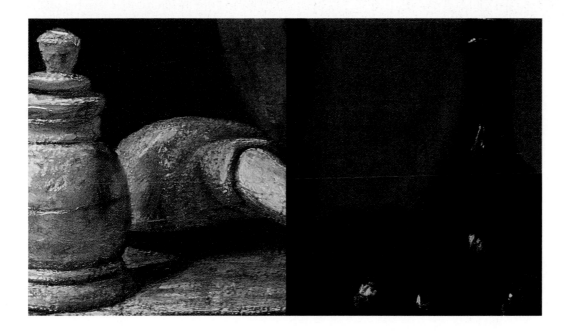

A Jean-Baptiste-Siméon Chardin. *A "Lean Diet" with Cooking Utensils* (detail). 1731. Oil on canvas, 13″ × 16¹/₄″. Musce du Louvre, Paris. Copyright Erich Lessing/Art Resource, NY.

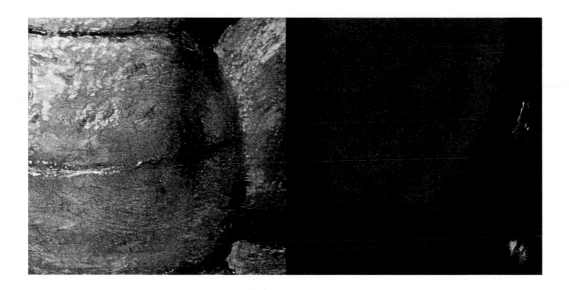

B Jean-Baptiste-Siméon Chardin. *A "Lean Diet" with Cooking Utensils* (detail). 1731. Oil on canvas, 13″ × 16¹/₄″. Musee du Louvre, Paris. Copyright Erich Lessing/Art Resource, NY.

The concept of middle color is certainly tied to the idea of mixture. The eye will select or choose a middle color independent of any experience with actually mixing paint, inks, dyes, or light. So, how is it we recognize the "middle mixture" between two colors if not by practical experience? The recognition of a middle color is a perception of interval and a sensitivity to border relationships.

The middle color is confirmed by the Munsell System: It is the color midway between the two parent colors in this three-dimensional model. This can be traced by equal visual steps.

When the middle color is placed between the two parent colors, there is a suggestion of a transparency. It appears that the lighter of the two colors has passed over the other color, like a film or **transparent** medium. The middle color reads like a mixture area. While this is visually compelling, most transparent media will actually darken when they overlap, behaving like two filters that allow less light to pass through. Nevertheless, the suggestion of transparency is an undeniable quality when the middle color is placed between the two parent colors.

This middle color relationship occurs in several places in Anne Ryan's collage in **A.** Some of the materials are thin and translucent or transparent and create mixtures. Other apparent mixtures are the result of found materials that evoke a sense of transparency. The color sets in **B** are drawn from the collage and suggest a middle color and a sense of transparency.

B The middle color suggests mixture and transparency.

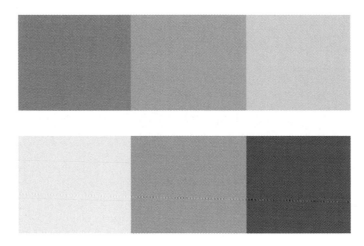

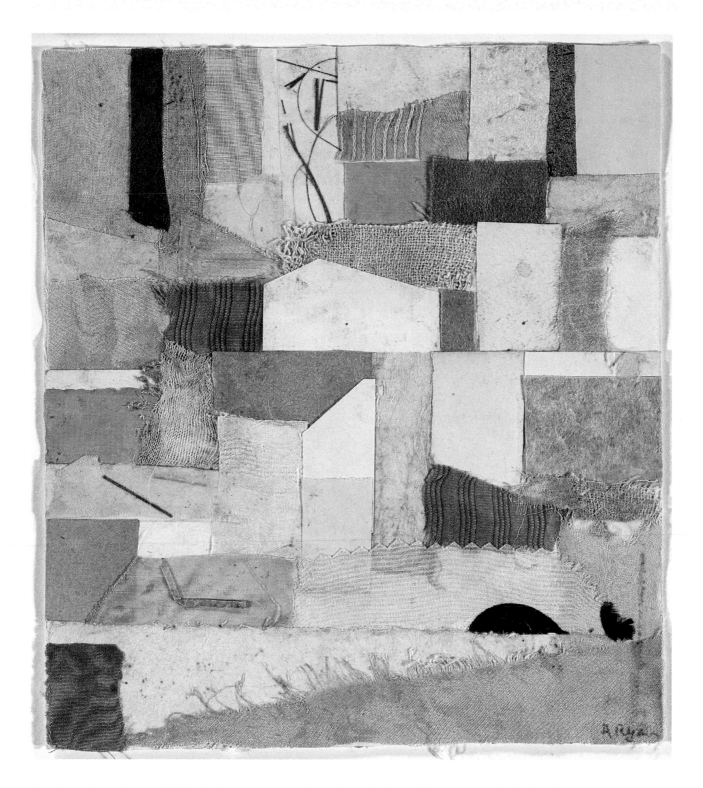

A Anne Ryan. *No. 74*, 1948/1954, fabric and paper collage. *8″ × 7″* unframed. Collection of Walker Art Center, Minneapolis. Gift of Elizabeth McFadden, 1979. Accession number 1979.4.

When colors are presented in a gradation, each step reads as a mixture of the two adjacent colors. If the steps are equal visual steps, then this mixture reads as the middle between the two adjacent colors.

Karl Gerstner's *Color Sound St. Jacques 6 Introversion* **(A)** is a gradation that moves from a yellow at the edge of the composition to an intense pink at the center. This progression moves through hue steps with little change in value or intensity. Each step is a consistent color; however, the borders behave in contrasting ways. The orange steps look more pink against the yellow border and more yellow against the pink border. In effect, this solid color seems to gradate.

This effect is called **interpenetration.** An otherwise smooth, consistent color will visually dissolve into the two parent colors. Simply enough, the orange looks more pink in comparison to the yellow parent, and more yellow in contrast with the pink parent.

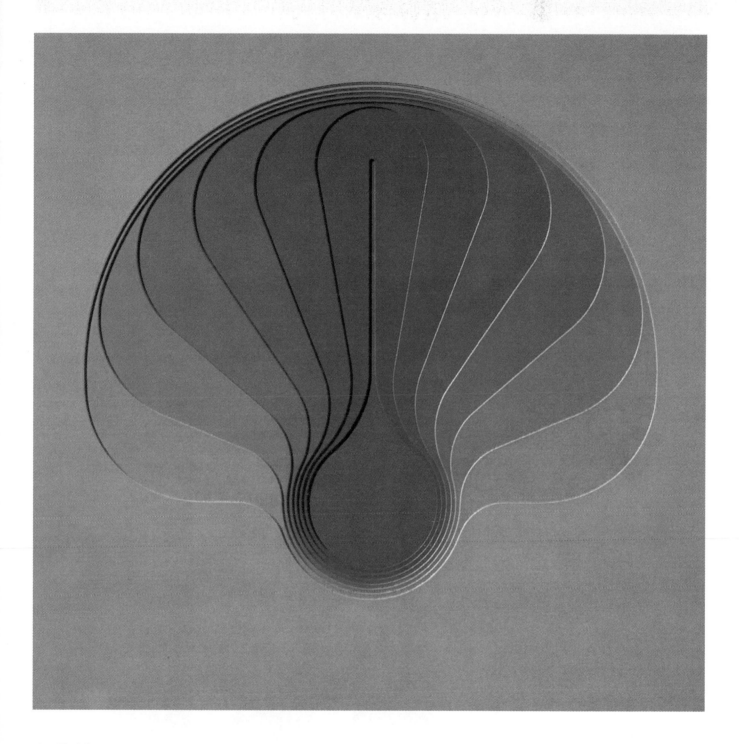

A Karl Gerstner. *Color Sound St. Jacques 6 Introversion.* 1972–73, Intro Version. Nitrocellulose on phenolic plates, 24³/₄″ × 23³/₄″. Courtesy of Karl Gerstner.

As one hue takes on the color of another, the first can appear to sink back into the environment of that second color. A progression or gradation of color will suggest transparency and depth.

In **A** the cyan vertical strip appears to be overlapped by the red horizontal strip on the left. Here the horizontal borders are very high in contrast while the vertical borders are soft. This places the mixture color closer to the red and suppresses the cyan well "under" the red. By contrast, the vertical strip on the far right has contrasting vertical borders and soft horizontal borders. Now the mixture color is closer to the cyan and the cyan appears to be on top of the red. The middle mixture sits in a more ambiguous relationship to the cyan. Which strip is on top? Either reading is possible. This square can be read as occupying a middle distance between the other two mixture squares.

Illustration **B** offers a similar format to **A.** Here the three vertical strips seem to advance closer to the surface from behind the pale horizontal strip. As we read from left to right, the green vertical strips seem to emerge from a fog. This creates a situation similar to the **atmospheric perspective** seen in the painting by George Inness in **C.** This painting demonstrates how objects take on the color of the atmosphere as they recede into the distance.

Atmospheric perspective is related to film color. As transparent media (such as watercolor) or films (such as acetate) overlap, the film color becomes stronger. An interesting aspect of overlapping films is that for the visual steps to be equal, the progression must actually be geometric. For the steps to read as one, two, three equal steps, the film layers must progress as one, two, four layers of the media, doubling for each equal visual step.

See also Chapter 4, *Color in Practice: Two-Dimensional: Color and Light: Transparency and Translucency,* page 94.

A Transparency Studies

B Transparency Studies

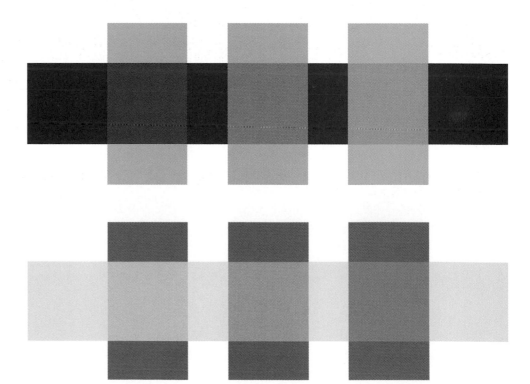

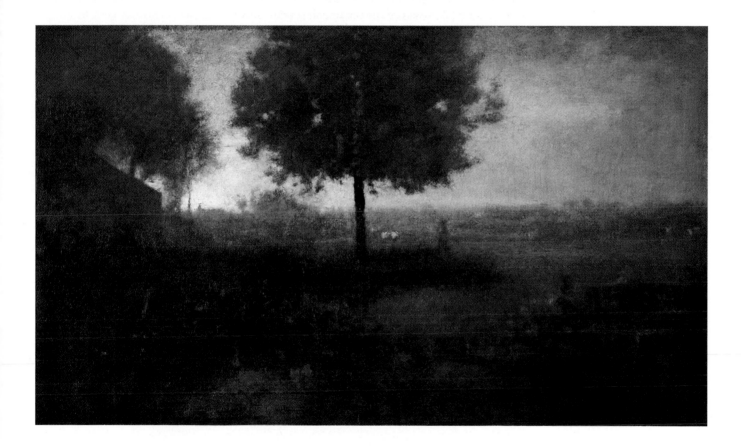

C George Inness. *Hazy Morning, Montclair, New Jersey, 1893.* Oil on canvas, 30″ × 50″. Collection of The Butler Institute of American Art, Youngstown, Ohio.

The border relationship between colors is a critical aspect of the interaction between them. One specific relationship, melting borders, may seem rare, but it is actually common enough to be observed around us.

Water towers in residential areas are sometimes painted pale sky colors to soften their presence. The lighter side of the white tower in **A** dissolves into the overcast sky. The dark tower in **B** stands in contrast to the blue sky.

The value relationship is the most important factor for a melting or dissolving border. If the values are even slightly different, the border will be more apparent. Two different hues of the same value **(C)** will have a softer border than two colors that are the same hue but a different value **(D).** In **C** the hues are similar, but they are different enough to be perceived from a distance. The border, however, is soft enough to dissolve at a distance.

C Equal Value, Difference in Hue

D Unequal Value, Same Hue

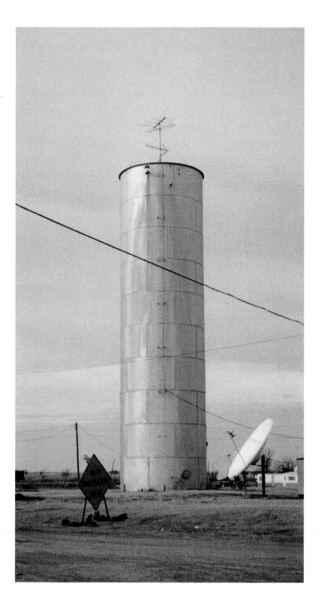

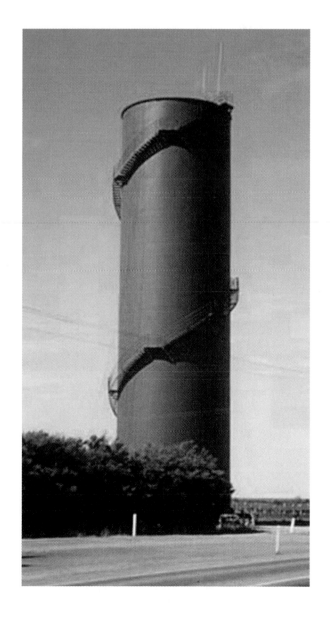

A Water Tower: *dissolving.* Photo by Michael A. Corley, www.frisco.org, Dallas, TX.

B Water Tower: *contrasting.* Courtesy Wentworth Shire Council, NSW, Australia.

The border between two colors will vibrate or scintillate under certain circumstances. This is more than simply a strong contrast between the colors. When the colors in each pair are equal in value and high in intensity, the effect is most pronounced. Red will vibrate with either blue or green, the other two light primaries **(A)**.

What constitutes a vibrating edge if not mere contrast? A flash of light or white will flicker at the edge, and in some cases a corresponding shadow or darker line will appear as well. Theoretically this is due to an inability of the retina's rods and cones to simultaneously focus on two disparate hues at the same value. This is especially true of blue and red. The flickering light at the boundary of vibrating colors is suggestive of the light produced in additive mixtures. This vibration has been exploited in poster art, such as in the example in **B** from the 1960s.

A Red Vibrating with Blue and Green

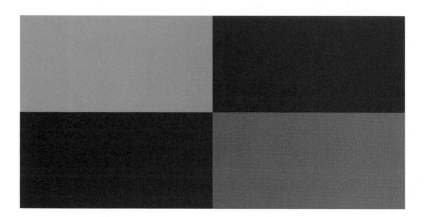

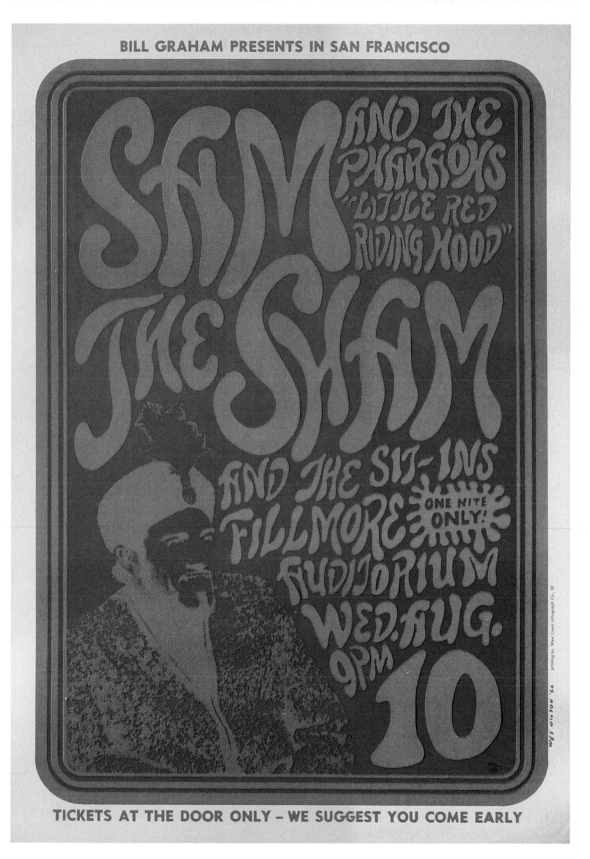

B Fillmore Poster: Sam the Sham and the Pharaohs. Artist Wes Wilson. Collection of Paul Olsen—olsenart.com.

Optical mixture occurs when small bits of color are repeated in a pattern. The eye will blend these colors into a visual mixture. The additive (light) mixtures of a computer or television screen exploit this effect. The result in this case is a true addition, such as red plus green creating yellow. Optical mixture also occurs with surface color, but the effect is an averaging of color, or **partitive mixture.**

The success of the partitive mixture depends on scale and viewing distance. The effect is stronger with smaller bits of color and most effective at a distance where the individual bits cannot be perceived. Common examples of this form of mixture include woven textiles, mosaic patterns, and the dot patterns of offset printing. The division of color in **pointillist** painting of the Post-Impressionist period is another example. In this latter case, the attempt was to evoke the qualities of light.

Surface colors cannot achieve the power of additive mixture. In actuality, the mixtures of a weaving may produce a less intense color than the parent colors. The woven sample in **A** is such an example. A magenta and a green combine to suggest a dull magenta that approaches grey.

Scale is critical to this effect. In larger amounts, the magenta and green would enhance each other's identity in vivid contrast. In optical mixture, the result is actually the opposite: The red and green give up their individual identity to form the resultant brown. A fine pattern of magenta and green will yield a smooth blend. A course pattern will not blend completely, but the two colors will start to merge in identity.

When the partitive mixture is a blend of two parent colors in equal amounts, the result suggests a middle color between them **(B).** This middle may not be the same color we would get with a paint mixture (which could be darker due to subtractive mixture). The middle color of a partitive mixture is consistent with the middle color in the Munsell System. A line through the three-dimensional color system can be tracked through a series of steps in hue, value, and chroma. The midpoint of this line will be the middle color and is consistent with partitive mixture.

See also Chapter 4, *Color in Practice: Color and Light: Optical Mixture,* page 96.

A Plaid (Prince Edward Island). Courtesy House of Tartan.

B Mixture effect: middle color.

The relationship between two colors can be understood as an interval—a distance apart in hue, value, and intensity. The lighter colors and darker colors in the quilt shown in **A** are separated by an interval of value and, to a lesser degree, hue.

The shift from the lighter range to the darker range is described as a **transposition of color,** much like a key change in music. This quilt is composed in a concentric pattern of diamonds that alternate as light and dark bands. There is a variety of colored fabrics in each band but the light-against-dark pattern is dominant. The overall pattern is given unity by a repetition of nearly black strips in the dark band and nearly white strips in the lighter band. The fabrics in the lighter bands all appear to be tints or mixtures with white. Optical mixture creates the suggestion of shadow and light or that the darker bands have been transposed to a lighter key.

Reds predominate throughout the quilt and the repetition of small pink squares contributes to this color dominance. The overall complexion of the quilt is reddish; however, a few blues are scattered around both the light and dark areas.

The dominance of red creates the effect of a constant surface that has been alternately illuminated and shaded. The lighter bands tend to have bluer colors meeting red or red-orange strips at the dark border. The slightly greater amount of blue in the lighter areas offers a hue contrast to the many red-orange strips in the dark areas.

See also Chapter 4, *Color in Practice: Two-Dimensional: Color and Light: Transposing Colors,* page 90.

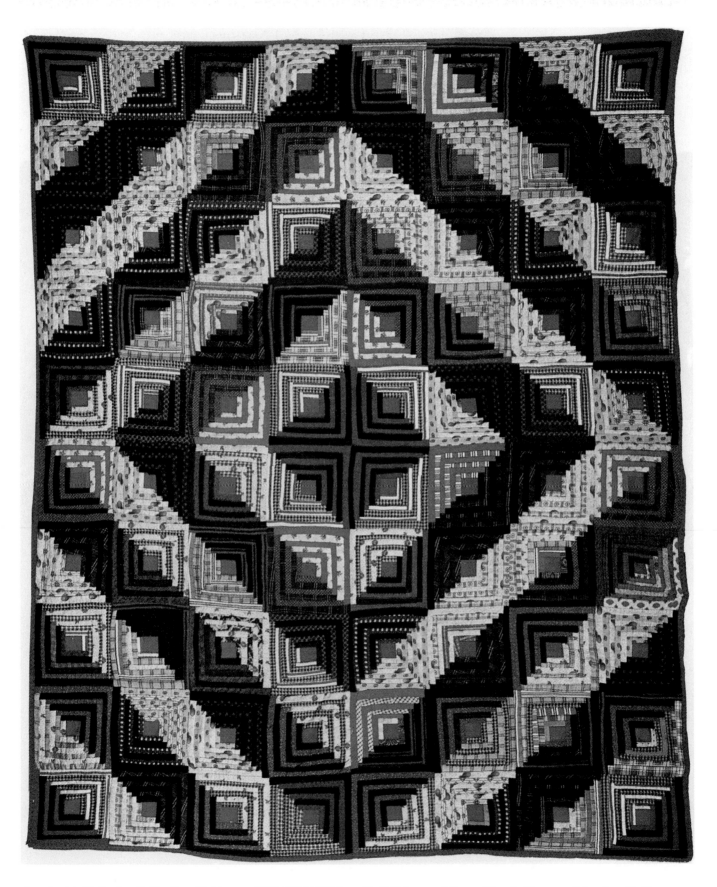

A Amish Quilt. *Log Cabin, Barn Raising.* ca. 1910. 88″ × 77″ from Cyril Nelson and Carter Houck, *Treasury of American Quilts,* (Greenwich House, 1982).

Any use of mixed colors extends a palette. A certain magic occurs when a range of colors seems to expand because of amount, repetition, surrounding color, border relationships, optical mixture, and all of these factors in varying degrees and combinations. So it is that we often see more than the simple palette that went into a design.

Aboriginal artworks, such as the bark painting shown in **A,** were made of a few colors or the **earth pigments** available to the indigenous people. In the hands of such artists, the palette does not feel like a limitation. Small strokes of white create optical mixtures with yellow and red to produce tints. The dull red ground color appears almost violet in contrast to the yellow ochre figures. For earlier indigenous artists, making the most of a palette was a practical matter. Today a broader palette of commercial colors exists, but the principles remain the same.

The woven fabric in **B** consists of three colors. This simple palette is extended to suggest at least five colors. Red, blue, and green expand to include blue-green, magenta, and even a yellow cast to the red-and-green mixture area.

B *Agnew Family Tartan*. Courtesy House of Tartan.

A Australian Aboriginal, *Bark Painting*, #E0083, James E. Sleeper Collection. Museum of
Anthropology, University of Kansas.

A thorough understanding of color systems and interactions may give you the training to mix and match color to perfection and to take into account highly specific lighting criteria. You might have the skill to assure us that the contents of every can of tomato soup will be the same color, but even then you may not be the next Andy Warhol **(A).**

Andy Warhol's prints and paintings not only comment on commercial products but also reflect a keen awareness of color interaction and theory in practice. Some of his images use color like a map: Four colors are sufficient to differentiate the shapes from one another. Other images use color transparently to define shapes independent from an outlined image. Still other works (in series) will effectively demonstrate a variety of color structures from image to image, including:

monochrome: variation on a single hue
analogous colors: adjacent hues on the color wheel
triadic colors: three colors equally spaced on the color wheel
complementary colors: opposites on the color wheel
vibrating colors: a sense of flickering light at the edge
melting colors: soft boundary or edge
earth colors: browns, ochres, and so on

These relationships are easy to see among the variations shown in **(B).**

Warhol is also the artist who, through repeated use of the soup can image, called attention to the consistent flavor and color of tomato soup.

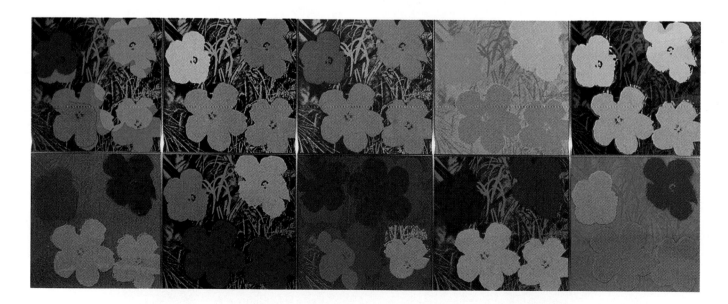

B Andy Warhol, *Flowers.* 1970. Portfolio of 10 serigraphs, 76/250, 35⅞″ × 35¹¹/₁₆″ each. Collection of the Modern Art Museum of Fort Worth, The Beth Collins Memorial Trust. © 2003 Andy Warhol Foundation for the Visual Arts/ARS, New York.

A Andy Warhol, *Campbell's Soup I (Tomato).* 1968. One from a portfolio of ten screen prints on
paper, 35″ × 23″. The Andy Warhol Foundation, Inc./Art Resource, NY. © 2003 Andy Warhol
Foundation for the Visual Arts/ARS, New York.

Among all the elements of two-dimensional composition—including line, shape, value, and placement—perhaps color is the most potent at creating emphasis. On a late autumn day a hunter will count on "hunter orange" to ensure his visibility and safety in the woods. Red stop signs and yellow caution warnings are meant to catch our eye even in a cluttered environment.

Emphasis is created by contrast. The contrast can be that of an intense color against a dull setting or it can be a contrast of hue. A strong emphasis can define the focus of a composition and point to the meaning of an image. This is the case with Romare Bearden's *Prince Cinqué* (A). Cinqué, the leader of a revolt on the *Amistad* slave ship, is the obvious focus of the composition. A large, grey shape of the African continent overlaps Cinqué's head, yet the face is still the stronger focal point. This emphasis is created by the hue contrast between the brown and the blue.

The composition of Bearden's print is dominated by blue. Accents of a nearly complementary orange and related browns point to different aspects of the story, including the uprising on the ship. The artist successfully uses contrast of hue to create emphasis and weaves this element among others to maintain our interest in the composition and the narrative.

See also Chapter 5, *Color in Practice: Three-Dimensional: Emphasis,* page 140.

A Romare Bearden. *Prince Cinqué*. 1971. Screen print. Library of Congress, Prints and Photographs
Division. © Romare Bearden Foundation/Licensed by VAGA, New York, New York.

A simple and common structure for color composition is the triadic color scheme. The triad can be any three colors that are equidistant on the color wheel. Goethe's color triangle points to the most obvious such triad: red, yellow, and blue. Such a structure is seen as balanced much like the equilateral triangle that connects the three colors.

The vivid contrast of red, yellow, and blue is utilized in product labels to catch our attention. This ubiquitous strategy is demonstrated in the photograph shown in **A.** Andreas Gursky's large-scale photograph reveals a panorama of red, yellow, and blue packaging. Ironically the voice of each brand is lost in the chorus of thousands of similar labels. Gursky's image of a discount store is reminiscent of Piet Mondrian's *Broadway Boogie Woogie* **(B).** Both compositions capture dynamism within a gridlike structure through the use of triadic color.

A Andreas Gursky. *99 Cent.* 1999. Chromogenic color print. 6'9½" × 11' (207 × 337 cm).
© 2003 Monika Sprüth Gallery, Cologne/Artists Rights Society (ARS), New York/
VG Bild-Kunst, Bonn. Courtesy the artist and Matthew Marks Gallery, New York.

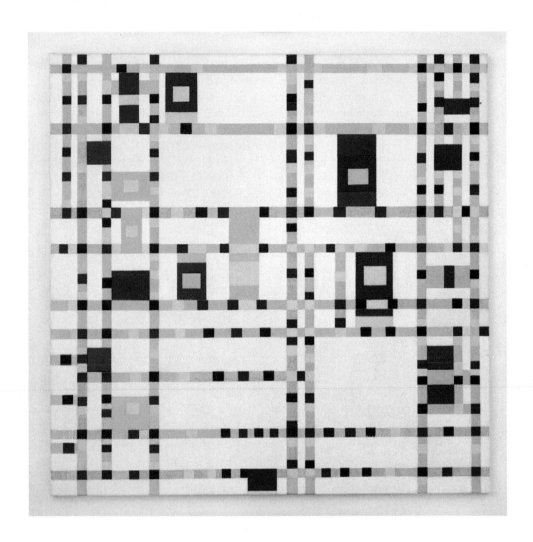

B Piet Mondrian. *Broadway Boogie Woogie*. 1942–1943. Oil on canvas. 50″ × 50″ (127 × 127 cm).
Digital Image © The Museum of Modern Art/Licensed by SCALA/Art Resource, NY.
© 2003 Mondrian/Holtzman Trust/Artists Rights Society (ARS), New York.

A **monochromatic** composition is one limited to a single hue. This seems to imply a less satisfying or dynamic experience, even a recipe for boredom. The question might be: "Why monochrome, when another palette would be more interesting?"

A monochromatic image may be simply the result of an economic choice, such as choosing less expensive cyanotype photography rather than other processes. The choice can also be a conceptual one based on the artist's intentions. Painter Mark Tansey relies on monochrome to unify a montage of images from a variety of sources **(A)**. In Tansey's work, texture is often emphasized, and this would be less obvious in a **polychrome** (a multi-colored composition).

Karl Blossfeldt created and collected many photographs of plant forms as a reference source for his sculpture students. Illustration **B,** *Pumpkin Tendrils and Bryon,* is one such collection. The assortment of grey gelatin silver and brown gelatin silver photographs create a composition dominated by nearly neutral warm grey.

The warm greys contain a bit of brown so are not strictly **achromatic** (lacking hue). The single more intense brown image becomes a point of emphasis, even among the exotic collection of spiral forms. A slower reading of the page may lead you to more interesting forms, but the power of intensity used to catch our attention is obvious.

Within each separate photograph (even the more intense brown example) one can see how a monochrome keeps the emphasis on shape and form.

See also Chapter 5, *Color in Practice: Three-Dimensional: Unity with Variety,* page 132.

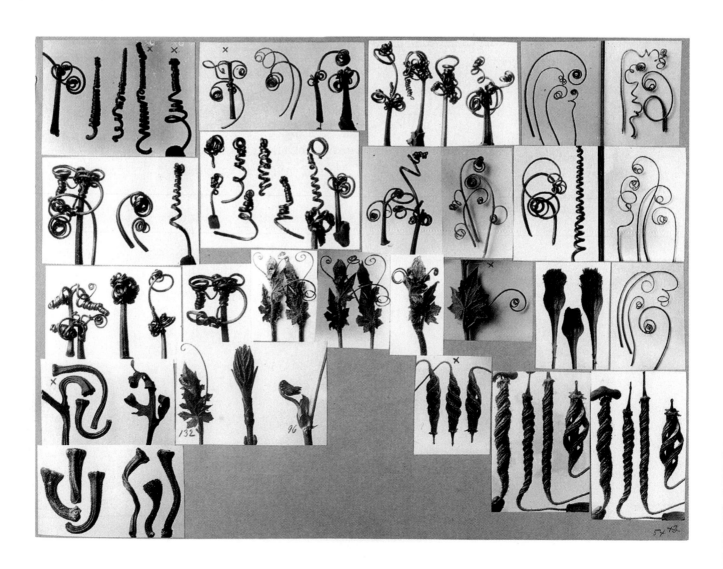

A Mark Tansey. *Close Reading.* 1990. Oil on canvas. 121½″ × 46⅛″. Collection of the Modern Art Museum of Fort Worth. Museum Purchase, Sid W. Richardson Foundation Endowment Fund. Courtesy of Mark Tansey.

B Opposite page: Karl Blossfeldt. *Pumpkin Tendrils and Bryon.* c. 1920s, photo collage. From *Karl Blossfeldt Working Collages,* Plate 29, Courtesy of the MIT Press, Cambridge, MA. © 2003 Karl Blossfeldt Archiv / Ann u. Jürgen Wilde, Köln/Artists Rights Society (ARS), NY.

A subtle color composition will often turn out to be a range of analogous colors, or hues adjacent on the color wheel. Analogous colors are often found in the natural world, from the range of human complexions to the variety of foliage colors in a forest. An analogous palette is often used when simplicity and order are desired.

The logo design for British Petroleum **(A)** is an example of an analogous palette used to create an easily recognizable corporate identity. The radiating design gradates from yellow to an adjacent green hue. These colors have an association with the sun and plants, lending a "green" image to this energy company.

The Japanese screen shown in **(B)** employs a similar analogous palette of gold and green. This image is a detail: one of a pair of panels depicting *Willows by the Uji Bridge*.

A BP Logo. Courtesy of BP p.l.c.

B *Willows by the Uji Bridge,* Japanese. Ink, color, and gold on paper. 154.40 cm. x 323.60 cm. Accession Number 1969.110b. Worcester Art Museum, Worcester, Massachusetts. Alexander H. Bullock Fund.

A striking and dramatic contrast is often associated with the use of complementary colors. A complementary pairing can suggest a balance of opposites or a clash of opposites, depending on scale, intensity, and the amount of each color. A complementary palette can also lead to a subtle palette if the colors are mixed and neutralized.

While complementary colors are often an aspect of a composition, rarely will you find an obvious or dominating complementary pairing. A more complex color structure can be developed from **split complementaries** or a color and hues adjacent to the complement.

David Hockney's *Portrait of an Artist (Pool with Two Figures)* **(A)** takes advantage of red in contrast to a complementary blue-green and the adjacent cyan blues and forest greens. The smaller area of intense red is balanced by a larger amount of greens, blue-greens, and blues. The closest hue to the complement of the red can be found in the distant hill adjacent to the figure's head.

It is not unusual to see a small amount of red balanced by larger areas of the more soothing complement. The human eye registers more intensity levels for red, and evidently it takes a lesser amount of red to balance the complement.

A David Hockney. *Portrait of an Artist (Pool with Two Figures)*. 1972. Acrylic on canvas. 84″ × 120″ (214 × 304.8 cm).
© David Hockney.

The color structures discussed in the preceding sections—triadic, monochromatic, analogous, and complementary—are often referred to as **color harmonies.** A sense of order (such as a gradation of analogous colors) and balance (such as a complementary pairing) is equated with harmony. It is also obvious that simple gradations or triads may be boring or predictable in contrast to the lively and eccentric color combinations that emerge in art, fashion, and popular culture. Thus, one person's (or culture's) sense of harmony may not be the same as another's.

In music the harmonic intervals of thirds, fifths, and octaves may be successfully composed in a Viennese waltz. Those same intervals may annoy us as elevator music. Musical intervals of seconds, fourths, or sevenths may sound discordant when randomly plucked by a novice guitarist, or they may be part of a memorable blues improvisation. Dissonant or discordant intervals are often a key ingredient for expression in music and art.

Harmonious color progressions are easier to define than discordant ones. Any two colors presented with their middle mixture will seem harmonious or resolved, as we have seen in examples in previous sections. Discord may be harder to define, but it is common to say, "Those colors just don't go together." An arbitrary collection of various hues, values, and intensities will more likely appear confusing or discordant. A case in point is a barrage of strip mall signs along a highway.

Discord as a lively ingredient can be seen at work in eye-catching advertising or as a spark of life in a painting. A pair of colors widely separated but not complementary is sometimes seen as discordant. Orange and purple are an example of this; yet, these colors are important to the mood of Archibald Motley's painting *Barbeque* **(A).** These colors convey a sense of a summer evening and perhaps even the flavors of the barbeque.

The potential creative use of colors in surprising juxtapositions, patterns, and amounts undermines any prescriptive notions of harmony and discord.

A Archibald Motley. *Barbeque*. ca. 1935. Oil on canvas. 39½″ × 44″. Howard University Gallery of Art.

Black and white are colors. If we point to a black rectangle and ask someone what color it is, the answer will inevitably be "black." This is true of white and grey as well. White, black, and grey are colors, but they are colors with very special properties. Black, white, and grey are, of course, neutral; they constitute that set of colors devoid of hue! This also means that they are without intensity, occupying the lowest, neutral place on the intensity scale. Black and white also possess unique value properties—black is the very darkest color, white the lightest. Black and white may be thought of as one-dimensional colors, because they manifest only one of the three fundamental properties of color.

Because of these unique properties, black, white, and grey have long served important roles as color in paintings, textiles, and other media. In **A** see how Henri Matisse uses black as a color in its own right. He has constructed the painting of four major values, from darkest to lightest—black, red-orange, blue, and white. Black serves as just another color here, a sensation among other sensations. In addition, it provides the heavy structural framework that the other colors hang from—the lead in the stained glass window. The red-orange violin plus the table in the foreground are emphasized by hue. The white that is the light seen through the window, and the white shutter itself, are emphasized because of value.

Because black, white, and grey are **neutral,** they serve to enhance adjacent colors. Also, because they are neutral, they are extremely malleable, taking on the complementary properties of neighboring colors. However neutral grey may appear when viewed in isolation, it may appear to be tinged with any hue solely due to its context.

See also Chapter 3, *Color in Context: Afterimage,* page 40.

A Henri Matisse. *Interior with a Violin.* 1917–1918. Oil on canvas. Statens Museum for Kunst, Copenhagen, Denmark. Photographer: DOWIC Fotografi © 2003. © 2003 Artists Rights Society (ARS), New York.

From its inception, one of pictorial art's biggest challenges has been creating a naturalistic representation of space in a two-dimensional composition. There are many visual clues to suggest depth, including overlap, size, placement, and linear perspective. Painters since the Renaissance have utilized atmospheric perspective to suggest deep space in landscape paintings. Also referred to as **aerial perspective** or by the Latin term **sfumato,** atmospheric perspective is the effect of objects taking on the color of the atmosphere as they recede into the distance.

A Showery Afternoon by Junius R. Sloan **(A)** shows the effects of atmospheric perspective on contrasts of hue and value. The foreground consists of strong contrasts in light and shadow and intense warm colors, including red-orange. The distant hills are depicted in more subtle contrasts and take on the color of the sky and misty clouds. Simply enough, strong contrast and warm colors advance, and softer contrast and cool colors recede.

This method for creating depth in a two-dimensional image is not only a Western convention, but it also is evident in Chinese landscapes and Japanese screens. Forms emerge from the color of the **ground** on which they are painted or situated. That ground might be the white paper of a scroll or the gold surface of a folding screen. In this case, depth is not equated with blue but with the atmosphere of the support or surface.

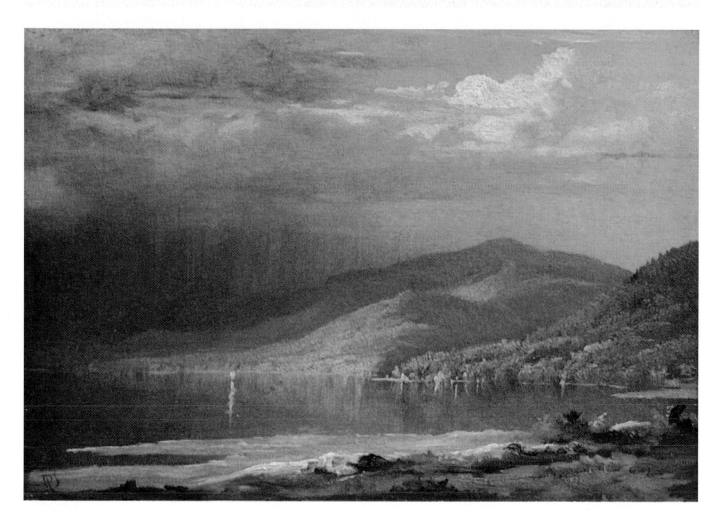

A Junius R. Sloan. *A Showery Afternoon on Lake George.* 1865. Oil on canvas on masonite. 10″ × 14″. Gift of Percy H. Sloan. Brauer Museum of Art, 53.01.226. Valparaiso University.

The spatial order of a representational image is typically predictable and consistent. Abstract and non-objective imagery is more likely to suggest an ambiguous space or to simply exist as a two-dimensional experience.

Josef Albers preferred the term *presentational* to describe his work. This term differentiated his paintings from representational work, but it also distinguished his work from *abstraction*. Abstraction implies that the painting is a symbol or sign for something other than itself. *Presentational* implies that *the painting* is the reality.

Albers's paintings and graphics *do* evoke spatial relationships. When asked whether the center square in his *Homage to the Square* paintings **(A)** receded or advanced, he replied that some will see it one way, and others just the opposite. His conclusion was that *both* responses are right. This dual reading can be called equivocal space.

Study for Homage to the Square, Early Diary demonstrates this phenomenon. The small blue square has several attributes, suggesting that it recedes in this composition:

Size (it is small)
Implied perspective (the corners of the squares form implied lines of one-point perspective)
Color (blue, associated with atmospheric perspective)

On the other hand, this painting has a unique value structure: the three hues are equal in value. This value relationship tends to flatten any spatial reading.

And finally, the yellow (a yellow leaning toward orange) and the pink are closer in hue. Since the yellow has a greater contrast to the blue and a softer border to the pink, the blue square seems to float above the yellow and pink.

From this simple composition of three colors, three spatial readings can be evoked.

A Josef Albers. *Study for Homage to the Square, Early Diary*. 1954. Oil on masonite. 15″ × 15″. Sheldon Memorial Art Gallery and Sculpture Garden, University of Nebraska–Lincoln. Nebraska Art Association, Thomas C. Woods Memorial © 2003 Artists Rights Society (ARS), New York. N-51.

Hans Hofmann was both a prominent painter and teacher. His ideas on the dynamics of a painting as a two-dimensional experience, free from illusionary deception, influenced a generation of artists.

For Hofmann the dynamics of "push" and "pull" replaced pictorial space, or the idea of the painting as a window. This painting may not provide a space to fall into like that of a landscape, but the shifting relationships of space and color engage our attention over time. *Veluti in Speculum* (A) demonstrates this new concept. The painting is larger than the viewer. The paint is obvious and often thick. The colors are intense. The shapes are rectangular, and perspective is not an element. This painting is a choreography of color and shape on the stage of the canvas, and these elements compete for our attention.

The broad central expanse of yellows tends to advance, causing the colors and shapes along the vertical edges to recede. However, a green rectangle seems to overlap the yellow, and this green rectangle connects to a constellation of similar rectangles (red and blue) to the right. Now they advance, pushing the yellow back. In the lower left corner, a dark brown-and-blue shape overlaps the yellow. This same pair can drop back when a visual connection is made to the blue in the upper right corner.

A Hans Hofmann (American, born in Germany 1880–1966). *Veluti in Speculum.* 1962. Oil on canvas, 85¼″ × 73½″ (215.9 × 186.7 cm). The Metropolitan Museum of Art, Purchase, Gift of Mr. and Mrs. Richard Rogers, by exchange, and Francis Lathrop Fund, 1963. (63.225) Photograph © 1999 The Metropolitan Museum of Art.

John Singer Sargent's painting of Claude Monet at work **(A)** is also a study in light. The two figures sit in the diffused light at the edge of the woods. A pattern of light and shadow plays across the woman's white dress. Beyond a grove of trees we can see the bright light on an open field.

A pattern of light and shadow in a painting is called **chiaroscuro.** You can see this pattern in Sargent's painting. The light comes from above left and shadows are on the right side of trees and figures. This is a subtle pattern because the figures apparently sit under a canopy of leaves.

What accounts for the luminous quality of this picture? The pattern of shaded trees against the distant lighter area is one factor, but so is the contrast of warm and cool between light and shadow. Lighter areas take on a yellow-orange hue, and shaded areas are predominantly blue in hue. The cooler shadows reflect the indirect light of the blue sky, while the bright areas reflect direct sunlight.

This contrast of **warm and cool** is most pronounced in morning and afternoon, which is evident in Claude Monet's paintings of haystacks, poplars, and the Rouen Cathedral. Impressionist works such as his reveal that the suggestion of light and shadow is not simply a matter of a color shifting toward white and black. In fact, such a palette would produce an unconvincing and lifeless quality.

See also Chapter 1, *Introduction: Color in Context,* page 14.

A John Singer Sargent. *Claude Monet Painting by the Edge of a Wood.* c. 1887. Oil on canvas, 54 × 64.8 cm. Copyright Tate Gallery, London/Art Resource, NY.

Just as a melody can shift in key when transposed for a different instrument, a pattern of colors is transposed as it moves from sunlight into shadow. This shift in key can be felt in Neil Welliver's painting *Shadow* **(A).**

The suggestion of a shadow crossing a brilliantly lit hillside is evoked through the entire collection of color changes. The stripe-like vertical tree trunks of pines and birches each change at the breaking point of light and shadow. The snow on the tree limbs is lighter than the cool "blue" snow on the ground. The sum of each of these color decisions makes the shadow almost palpable.

Welliver chooses his colors to evoke a sensation in a manner similar to that of a quilt-maker selecting fabrics for a quilt of sunshine and shadow. He has said that his color choices do not copy the surface appearances of nature, and were he to put this paint on a tree or rock, it certainly would not match. What the painter must do is transpose the sensation to his palette. The reflected light of paint will never be as luminous as actual light. In this way, to the extent that the picture is a "representation," the entire painting is a transposition of an experience in nature.

See also Chapter 3, *Color in Context: Color Transposition,* page 62.

A Neil Welliver. *Shadow.* 1977. Oil on canvas, 96″ × 96″. Digital Image © The Museum of Modern Art/Licensed by SCALA/Art Resource, NY. © Neil Welliver. Courtesy Alexandre Gallery, New York.

Various light sources have differing color properties. Daylight can vary from slightly yellow in early morning, to neutral at noon, to red by late afternoon. Moonlight has a cool appearance. Tungsten lighting is warm and lacking in the blue end of the spectrum. Other light sources produce only selected wavelengths (not a continuous spectrum), and our eye "fills in" the gaps or missing parts of the spectrum. Some sources, such as mercury vapor, leave out areas of the spectrum, and under such lighting a red car might look grey in the parking lot at night. The CIE System plots the spectrum for different light sources.

A walk through the city at night reveals different light coming from the variety of windows. An office tower may give off a white with a slight green quality of fluorescent lighting. A room with only the TV on will give off a blue light, while standard incandescent lighting will create an orange glow. These varied color temperatures of light present an opportunity and challenge for photographers. The photograph of a city street at night **(A)** by Lewis Baltz captures a moment of competing light sources.

A photographic print is first recorded in negative form. The positive image is a function of how much red, blue, and green light enters the lens of the camera from the source or subject. (Remember: white light is equal parts red, green, and blue light.) The negative has three layers of emulsion. Each is sensitive to red, blue, and green light, and each creates a negative image of the subject in the complementary color—cyan, yellow, and magenta:

The cyan layer records the negative image of the red component.
The yellow layer records the negative image of the blue component.
The magenta layer records the negative image of the green component.

At the time of printing, the image is reversed as red, green, and blue light pass through the negative and the image is recorded on paper, revealing the positive image. This process is subtractive. For example, the cyan layer of the negative will act as a filter, blocking the passage of red light but passing the blue and green light and exposing the blue- and green-sensitive layers of the printing paper. The blue- and green-sensitive layers of the paper produce yellow and magenta dye. When viewed by white light (RGB light), the yellow dye absorbs the blue light, and the magenta dye absorbs the green light. With no cyan dye present, the red light travels to the white paper base and bounces back out to our eye, and we see the color red.

See also Chapter 2, *Color Systems: The CIE System*, page 34.

A Lewis Baltz, *Rule Without Exception*, 1991. © Lewis Baltz.

A **transparent** medium allows a viewer to see through it and recognize objects and shapes on the other side. This is true of colored glass that alters the color of what we see. A **translucent** medium or substance allows some light to pass through but not images. A translucent leaf will glow yellow-green when backlit by the sun.

The twentieth-century philosopher Ludwig Wittgenstein collected his thoughts on color, perception, and communication in his influential work *Remarks on Color*. Among other phenomena, he speculated on the nature of transparency and observed, for example, that green glass appears transparent while coloring the objects we see through it with a green hue. He also observed that there is no transparent white; any shift of a transparent medium toward white (such as adding white paint to a mixture) is also by nature a shift toward **opacity**.

Anyone who has observed a stained glass window with light passing through it has seen the intensity of such color **(A)**. Similarly, a glaze of transparent ultramarine blue paint applied over a white ground will be *more* intense than a similar value of ultramarine blue tinted in mixture with white paint. The glaze allows light to pass through the surface of the paint to the white ground and reflect back through the blue, just as light passes through stained glass. The result is a more intense blue than the blue-and-white paint mixture.

Painters have the option of using transparent or opaque media. Transparent media such as watercolors and oil glazes allow the painter to mix colors "indirectly" through overlapping films or layers. A red glaze over a yellow base color will produce an orange. Opaque media are typically mixed on the palette and applied in a "direct" manner. Either method can produce a remarkable range of color interactions, including the *suggestion* or *illusion* of transparency, such as a representational painting of water or glass.

Oil and acrylic paints can be used in either opaque **impastos** (thick applications) or transparent **glazes.** Watercolors are thought of as a transparent media, but gouache is an opaque watercolor favored by designers for its ability to uniformly cover a surface with a thin coat. While any color can be diluted and thus become more transparent, certain colors, such as alizarin crimson or ultramarine blue, are inherently more transparent. Dioxazine purple appears very intense when applied in a thin coat over a white ground. That intensity will increase with several thin glazes, but additional layers will start to darken, almost approaching black. This illustrates the difference between visual intensity (or chroma in the Munsell System) and pigment saturation. Many layers of dioxazine purple act like a filter, allowing less light to reach the white ground and reflect back through to reveal the color. Cadmium red is an example of a more opaque pigment, and its covering ability is easy to see. This color does not require the white ground to illuminate it, and since the hue is inherently lighter to the human eye, multiple coats do not appear dark as the previously mentioned purple does.

A pigment chart for a quality paint manufacturer **(B)** shows many of the attributes discussed above. Notice how the intensity of Gamblin's Phthalo Emerald oil paint is visually more intense when stretched thin.

Note that "fillers" in cheap paint will render transparent pigments more opaque, just as extending the paint with more medium will render an opaque color more transparent.

The glowing red ear in Edouard Vuillard's painting *The Newspaper* **(C)** shows how light passing *through* a surface can produce intense color. Just as a child can see the light of a flashlight glow red through his or her hand, Vuillard suggests the illumination of the ear with a back light by his choice of hue, value, and intensity in painting both the ear and the surrounding background.

Two aspects of transparency (or translucency) are important to the painter:

Factual transparency: That is, transparent media
Implied transparency: The suggestion of transparency as a color interacts with adjacent colors

See also Chapter 3, *Color in Context: Transparency,* page 54 and Chapter 5, *Color in Practice: Three-Dimensional: Transparency,* page 126.

A Marc Chagall. *Chagall Window.* U.N. Headquarters, New York. United Nations.
© 2003 Artists Rights Society (ARS), New York/ADAGP, Paris.

B Gamblin Artists oil paint.
Phthalo Green Emerald
tint © Gamblin Artists
Colors Co.

C Edouard Vuillard. *The Newspaper,* between 1896 and 1898. Oil on cardboard. 12³/₄″ × 21″.
The Phillips Collection, Washington D.C.© 2003 Artists Rights Society (ARS), New York/
ADAGP, Paris.

Four-color, or CMYK, offset printing relies on optical mixture to produce a broad range of colors. This is also true of other media, such as large-scale mosaics and woven tapestries. Each of these media relies on light reflecting off the surface. This is different from a television screen that creates true additive or light mixture.

Painters have experimented with optical mixture since the period of the Impressionists. The Neo-Impressionist painter Georges Seurat hoped to achieve a luminous quality similar to light mixture. Seurat's small dots and dashes sparkle at a short viewing distance, merge and mix at a greater distance, and actually dull at a further distance. Scale and distance are critical to optical or partitive mixture.

Chuck Close is a contemporary painter and printmaker who has exploited the dynamics of optical mixture. At close range, a viewer is offered a complex array of colored marks in a grid. It is only at some distance from these large-scale paintings and prints that a viewer sees the rather coarse marks begin to resolve into a portrait.

Each unit of the grid typically has three colors, and these colors are sometimes as divergent as cyan, pink, and yellow. The colors blend most easily when their values are the same. An illuminated area will be dominated by clusters of light values, and shaded areas will be dominated by clusters of different hues at a similar dark value. Bits of dark in lighter areas and light in darker areas provide texture and a sense of detail.

Chuck Close has said that he likes his work to "simultaneously come together and fall apart." *Self Portrait 2000* **(A)** demonstrates this tension. We alternately see the portrait and formal structure that creates it.

See also Chapter 3, *Color in Context: Optical Mixture: Partitive Mixture,* page 60.

A Chuck Close. *Self Portrait 2000*. Screenprint. Image size: 58³/₈″ × 48″. Paper size: 65¹/₂″ × 54¹/₄″. Published by Pace Editions, Inc. Edition of 80. © Chuck Close and Pace Editions, Inc.

The painter who works in oils, the graphic designer who uses gouache, and even the home-owner involved in a painting project are aware that color decisions are dependent on an understanding of this wet messy stuff with pigment suspended in it. Painter Philip Guston observed that painters essentially push around dirt mixed with oil. In fact earth colors such as burnt sienna, yellow ochre, and burnt umber are just that. Many newer colors (such as phthalocyanine) are modern organic compounds developed in the twentieth century.

All paints consist minimally of three components:

Pigment is finely ground particles that form the colorant. Pigment can be ground minerals or organic compounds (that is, containing carbon and hydrogen).

Binder is the fluid medium that serves to adhere the pigment to a surface, such as linseed oil in oil paint, gum arabic in watercolor, or acrylic polymer in acrylic paint.

Solvent is a liquid that dilutes or extends the paint, such as turpentine for oil paints or water for acrylics or watercolors.

Every beginning painting student has experienced a palette (or mixing surface) that has degenerated to mud, the result of random attempts at mixture and the variety of once luminous colors all slipping into the same "muck" approaching grey or brown. We know this is the result of the inherently subtractive nature of paint mixing. If white is part of this mess, it will add its own pasty complexion and an opacity to the mix. This pasty mud left over on the palette or overworked on a painting bears little resemblance to a rich burnt umber applied in a glaze so that light can enter the surface of color. Yet, that same "muck" can suddenly become evocative if surrounded by the right colors, as we have seen in demonstrations of simultaneous contrast.

Paint in liquid form may not resemble the color when dry. Some colors may float to the surface when wet, only to be absorbed when thoroughly brushed into a surface. John Singer Sargent exploited the specific gravity of ultramarine blue watercolor as he painted shadows in sunlit landscapes. The blue would float to the surface in a puddle of paint, giving a cool cast to shadows.

Certain other attributes of paint may at first seem to be anomalies but are actually predictable. Black plus yellow seems to produce a green. Because "dark yellow" is not a common term and because many things we call "green" in nature resemble black-plus-yellow, it seems logical to call this olive color "green." Compare the mixture to a permanent green or phthalocyanine green, and the difference is apparent.

Frank Stella once observed that he wanted the color in his paintings to look as good as they did in the can. In fact the white space between colors limits their tendency to interact and enhances their individual identities **(A)**. Other painters aspire to an almost alchemical process where the "dirt and oil" become transformed like lead to gold. For example, the "golden" hair painted by Diego Velazquez **(B)** is not the result of gold paint but of a careful balancing of hue, value, intensity, and an attention to soft borders and contrast with the background.

B Diego Velazquez. *Las Meninas* (detail). 1656. Oil on canvas. 10′5″ × 9′1″. Museo del Prado, Madrid. Copyright Scala/Art Resource, NY.

A Frank Stella. *Harran II.* 1967. Polymer and fluorescent polymer paint on canvas, 120″ × 240″. Solomon R. Guggenheim Museum. Gift, Mr. Irving Blum. 1982, 82.2976. Photography by David Heald © The Solomon R. Guggenheim Foundation, New York. © 2003 Artists Rights Society (ARS), New York.

The surfaces of two-dimensional media and skin have always held a resonant relationship. Early cave paintings exploited the cave wall to suggest the hide and contours of an animal. With the evolution to oil paint in the fifteenth century, painters were able to exploit the medium's translucency and skin-like qualities for figure painting.

The human figure offers an obvious range of color, from pale pinks to ebony. Careful observation reveals the blush of capillaries below the skin's surface, the bluish variations of a bruise, the yellow cast of an illness such as jaundice, or the reflected color from clothing and surroundings. An apocryphal anecdote suggests that Monet commented on the colors his wife's body developed on her deathbed.

Alex Katz contrasts the complexion of two figures in the silkscreen print *September Afternoon* (A). The pale pink of the woman is lighter than the yellow background, while the orange of the male figure is darker than the yellow. The flat, stenciled color of this print lends itself to this shorthand expression of color relationships.

In contrast, Jenny Saville's painting *Hyphen* (B) exploits the versatility of oil paint from wet-into-wet blending to layered impastos. The unfinished quality of the painting suggests the process of paint becoming skin.

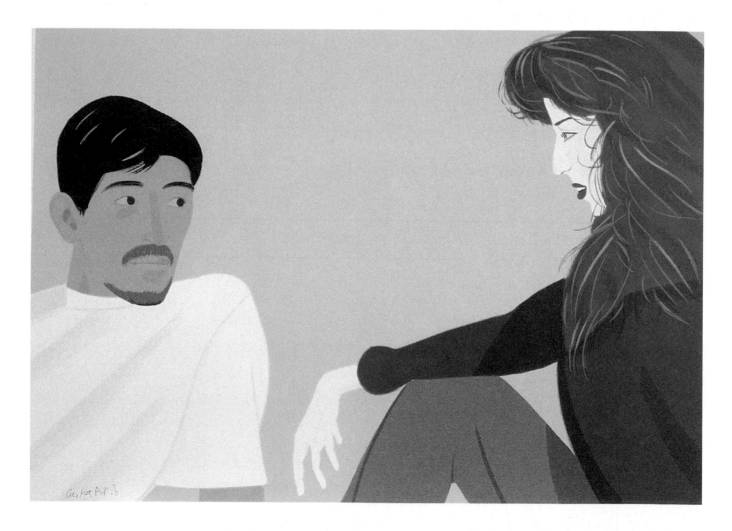

A Alex Katz. *September Afternoon.* 1994. Silkscreen. 28 colors. 29″ × 41¼″. © Alex Katz/ Licensed by VAGA, New York, NY.

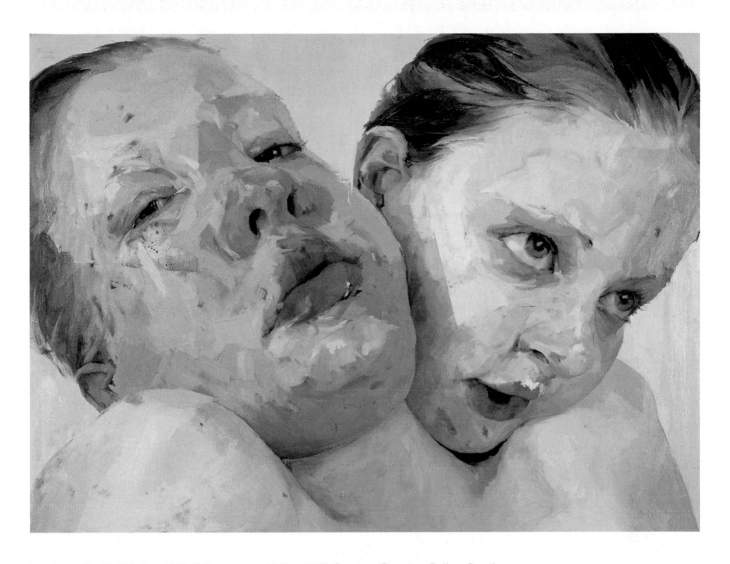

B Jenny Saville. *Hyphen*. 1999. Oil on canvas. 104″ × 144″. Courtesy Gagosian Gallery, London.

In his *Remarks on Color,* Wittgenstein asked how Rembrandt could paint a golden helmet without gold paint **(A).** Reflective surfaces offer a challenge to our understanding of color. We see in these surfaces the colors of the surrounding environment and something of an inherent color as well. In this way, colors are transposed in the reflection. Objects will take on a slightly green hue when reflected in a glass mirror. Reflections in gold will have a yellow cast.

Mary Cassatt's painting *The Tea* **(B)** presents the viewer with a still life of a tea service in the foreground. We understand immediately that the tray and teapot are silver, but what do we see with closer examination? The entire value range of this painting exists in the reflections from light to dark. The range of hues is more subdued, as are the intensities of any color we see: nearly neutral pinks, blues, and yellows. Perhaps most importantly, the greys all carry some aspect of hue. Nowhere do we detect that this is painted as only a grey-scale study.

Artist Robert Irwin may have answered Wittgenstein's question when he said, "Seeing is forgetting the name of the thing we see." With this fresh set of eyes, we are able to see the shapes and gradations of color in a gold or silver object and find their mixture on a palette.

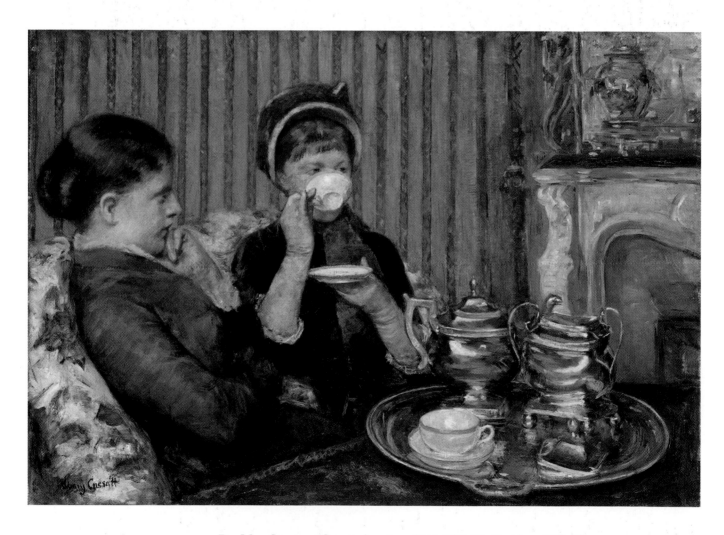

B Mary Stevenson Cassatt. American, 1844–1926. *The Tea,* about 1880. Oil on canvas, 25½″ × 36¼″. Museum of Fine Arts, Boston. M. Theresa B. Hopkins Fund, 42.178. © 2003 Museum of Fine Arts, Boston.

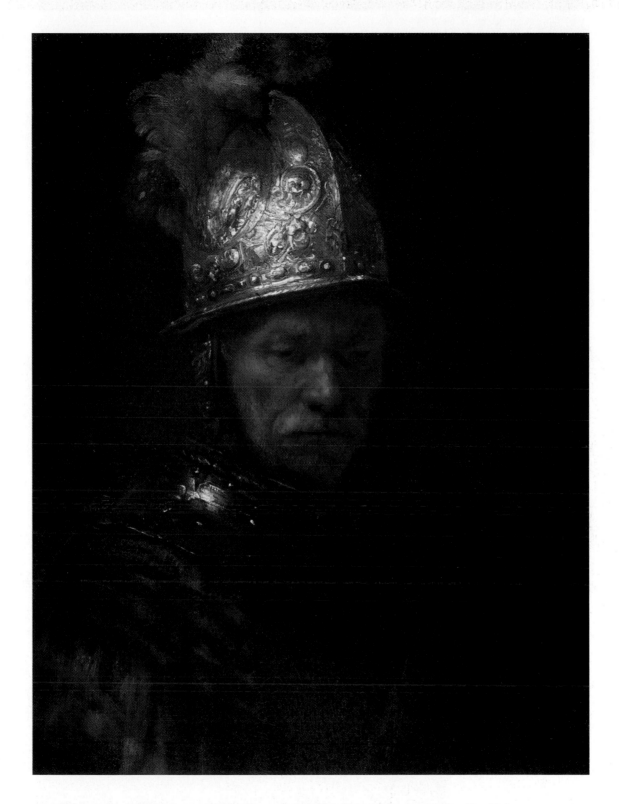

A Rembrandt van Rijn. *Man in Golden Helmet.* Anders/Staatlliche Museen zu Berline-PreuBishcer Kulturbesitz, Gemäldegalerie/Kaiser-Friedrich-Museums-Verein.

Luminosity is conveyed in two-dimensional art in a variety of forms, from the candlelight of a Latour painting to the glow of a Rothko abstraction. Wittgenstein observed, quite reasonably, that there is no such thing as a luminous grey. What does this mean? Luminosity is the appearance of light. If there is no lighter area for comparison, then we might read a grey as the lightest value—or effectively white in that context. The grey would appear luminous by "acting" like a white. This could be the case when we perceive a grey in a very dark setting. Is there any other situation in which a grey could be luminous, even as we are aware that it is, in fact, grey, with lighter and brighter values and colors nearby?

The Navajo weaving in **A** is just such a case offering a contradiction to Wittgenstein's proposition. In this case, a middle-value grey appears vibrant and luminous in juxtaposition to a yellow of the same value. The equal value relationship produces a vibrating boundary between the grey and yellow. An equal value relationship also occurs between the blue and grey in the Amish quilt shown in **B**. In both of these cases, a neutral or passive grey takes on an unexpected or luminous dynamic.

Grey is also subject to influence by a surrounding color to take on the hue of the complement. It would appear, then, that there *is* the potential for a luminous grey, when context encourages the grey to perform unexpectedly.

B *Sawtooth Diamond Quilt.* c. 1900. Lancaster County. 85″ × 87″. Jay and Susen Leary Collection. Courtesy of Jay and Susen Leary. From *A Gallery of Amish Quilts* by Robert Bishop and Elizabeth Safanda, copyright 1976 by E.P. Dutton & Co., Inc. Used by permission of Dutton, a division of Penguin Group (USA) Inc.

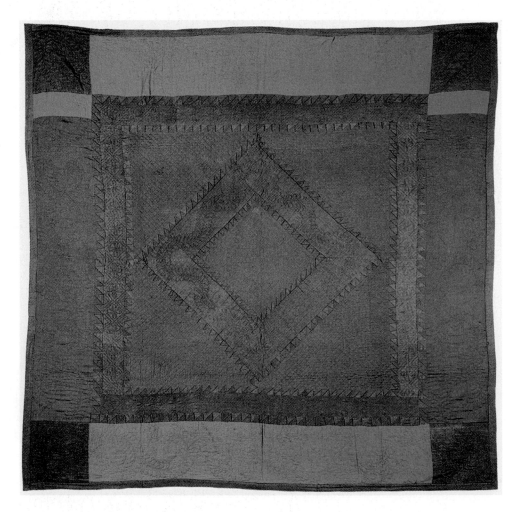

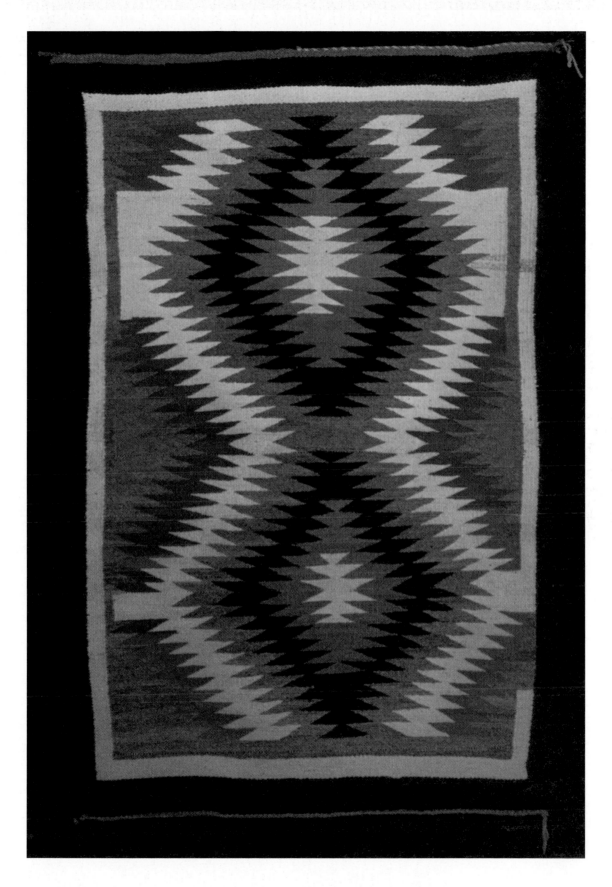

A Navajo rug, c. 1950s. School of American Research, Catalogue Number IAF.T734.

A symbolic use of color is usually culturally specific. Some overlap occurs between color signals from the natural world and our use of color to signify meaning. A combination of yellow and black signals danger in nature, and we use these colors to signify a warning. Many uses of color vary from culture to culture, however.

For example, during the medieval and Renaissance eras, Christian painters used a code of color to signify the Virgin Mary: blue and red. This ensured an understanding of the narrative meaning for frescoes and paintings for a largely illiterate audience. The cultural diversity of the twenty-first century would seem to ensure a multiplicity of meanings for color coding.

What are the implications of cultural diversity to any symbolic use of color in two-dimensional design and imagery? There is one answer for a narrow audience that may understand the codes, but there is no simple answer for work that aspires to a broader audience.

The broadest audience in the first world may be a consumer audience. In Western societies, "black" has been long associated with funerals and mourning. Virtually all associations with black (Halloween witches, the black hat for the outlaw) were negative or associated with death. And then came "black power," the little black dress, artists in black, and even black product labels to suggest quality.

At one time, black was considered the *last* color one would select for packaging food, yet in recent times it has become a symbol for high-end consumer goods. Illustration **A** shows a label design for a store-brand product. Black is used to assure the consumer that the product is upscale and of high quality.

An artist or designer who relies on color to convey symbolic content in graphic design, painting, or photography should count on the symbolism being highly fugitive.

A Product Label. Courtesy of The Kroger Co.

COLOR IN PRACTICE: THREE-DIMENSIONAL

INTRODUCTION

Though painting and graphics (two-dimensional surface color) are the traditional foci of the study of color, the world consists mostly of three-dimensional form. Consequently, the study of color would be incomplete if we failed to pay attention to a wide range of forms in space and light.

Three-dimensional form displays numerous attributes, and these attributes are always in situ, occupying a specific time and place. For example, the sculpture by Lucky DeBellevue, *Untitled*, 1999 **(A),** is made of common pipe cleaners (chenille stems) but embodies complex three-dimensional formal attributes. It does not simply present surface colors in juxtaposition. In fact, it is difficult to determine just where the *surface* is. This work is not just a web of color lines in space, as each line is made up of numerous fibers. These fibers create a strand of great density and richness, a deep velvet-like surface. On the macro level, the pipe-cleaner lines, as they traverse the sculpture, form groupings and subgroupings of color masses.

DeBellevue's *Untitled,* 1999, is also a cultural product—a sculpture that stands in relation to all sculpture that has come before it, from the long line of carved stone objects, cast and forged artifacts, found objects, and conceptual projects. It speaks not only of its own formal characteristics, but of the category of things we call *sculpture.*

Finally we may recognize in *Untitled,* 1999, similarities to other objects. Such similarities are known as *references.* DeBellevue's sculpture contains a rich reference life, from the natural (coral, bird's bones, fungi) to the artificial (fashion, primitive engineering, craft store hobbies). The color is naturalistic and/or surreal, for example, based not only on formal qualities but on its relationship to the work's history and references.

A Lucky DeBellevue. *Untitled.* 1999. Chenille Stems. 95″ × 88″ × 57″. Photo by Oren Slor. Courtesy of the artist and Feature Inc., New York.

In modernist sculpture and architecture (1860–1970), there has been a tendency to leave the material unpainted and unadorned. Modern concrete, steel, and glass buildings display nothing but the natural surfaces of the material used in the structure. Many modernist sculptors and architects insisted on allowing materials to "speak for themselves" and display their own straightforward properties. For them the modernist tenet "truth to materials" was a matter of integrity.

Paint and color enable us to create wondrous illusions of light and space. Paint and pigment are also substances with earthbound material properties; their fundamental physical nature has not been lost on painters in search of their own material's special truths and properties.

Paint can be built up into thick impastos, sanded like wood, and used as glue to affix objects. Painter Scott Richter pays homage to the sticky, viscous, dumb materiality of paint in his work, *3 Painters in Bed* (**A**). This work might serve to illustrate, in a most extreme fashion, Stuart Davis's notion that a painting "is an object made of paint." Richter makes palpable the pure physicality and sheer weight of paint, materially and metaphorically.

Respect for the integrity of materials is a hallmark of the arts, architecture, and the crafts. In ceramics, glass, woodworking, and basket weaving, there are many vehicles that literally embody color. Straw and vines and grasses, numerous varieties of wood, and clay bodies have color determined by their material nature and the geological attributes of their source. The contemporary Japanese dish shown in **B** is not a clay form, glazed blue and white; it is constructed of blue and white clay bodies rolled out in alternating strips and formed into a square plate. The color and material are one.

B Contemporary Japanese
Porcelain Dish. Photo
courtesy of Taylor Dabney.

A Scott Richter. *3 Painters in Bed*. 1998. Oil paint on paper; Steel table. 47″ × 36″ × 24″. © Scott Richter, courtesy of Elizabeth Harris Gallery, NY.

Painted three-dimensional objects, including architecture, that display more than one applied surface color are termed *polychromatic*. A broader, more contemporary approach to color and form encourages us to consider all multicolored objects, whether painted or not, polychromatic. If you think about it, almost everything in the world is polychromatic.

The material world is endowed with properties of both form and color. The most ordinary tree, for example, is a complex three-dimensional color structure. Shifts of hue, value, and intensity are integrated into the structural complexities of trunk, twisting limb, and leaf, all activated by the play of light on form.

Two disparate examples of polychromatic objects are a scientific model of Chloroplast (A) and a sculpture by Anne Truitt (B). The Chloroplast model is 75,000 times the size of a chloroplast cell. It is a form of realism on a monstrous scale made to instruct and to reveal the various parts of the cell. Like an accurate portrait painting, the color and shapes faithfully represent those of the miniscule original. In Anne Truitt's *A Wall for Apricots*, 1968, three colors painted on a square wooden column create the illusion of three stacked blocks and offer a set of complex interval relations—white, green, and yellow. We may conclude that polychrome occurs when form and color collide.

B Anne Truitt. *A Wall for Apricots.* 1968. © Anne Truitt.

A Bobbitt Chloroplast Model, BA-56-3622. Model is 11½″ × 11½″ × 9″ and is mounted on a base.
© Carolina Biological Supply Company. Used with permission.

Monochromatic sculpture—sculpture of a single material such as marble or bronze—is less widespread than we might be led to believe by looking at art history books. Much early tribal art utilized painted surfaces or was constructed of a variety of colored materials. Even early Egyptian and Greek sculpture was painted. Folk and outsider art works are often polychromatic, as are numerous sculptures from all historic periods. A particularly exuberant color sensibility exists today as boundaries between disciplines blur and restrictions fall by the wayside. Digital technology and new materials, such as plastics, foams, and laminates, have also opened the door to color experimentation.

This fifteenth-century figurative relief **(A)** is sensitively painted in red, brown, blue, and grey and gilded in gold. Its color represents a fairly common hybrid of two systems:

- A utilization of the color of the materials with which it is made—gold, paint, and wood. Some of the wood remains exposed (quasi-truth-to-materials).
- The employment of what is assuredly the most common system of color use—**local color**—color that mimics or reproduces the color of the subject matter, such as when a painter uses a specific red for a chair in a painting because it matches the red of the observed chair.

One of the most successful and delightful public sculptures in recent time was Jeff Koons's *Flowering Puppy*, 1992 **(B),** an outdoor public work that consisted of thousands of live flowering plants on a form the shape of a colossal terrier. In spite of its height, more than forty feet tall, its subject matter and material rendered this sculpture decidedly anti-heroic. *Flowering Puppy* resembled an Impressionist painting consisting of countless dabs of complementary green and red and white paint, but these dabs were flowering live plants. The colors were vivid but the form was soft as the leaves and flowers moved gently in the breeze.

A Michael Pacher, *Annunciation.* 1471–1475. Carved, painted, and gilded wood panel from the Gothic altar in the St. Erasmus Chapel. Foto: George Tatge. © Alinari/ SEAT/Art Resource, NY.

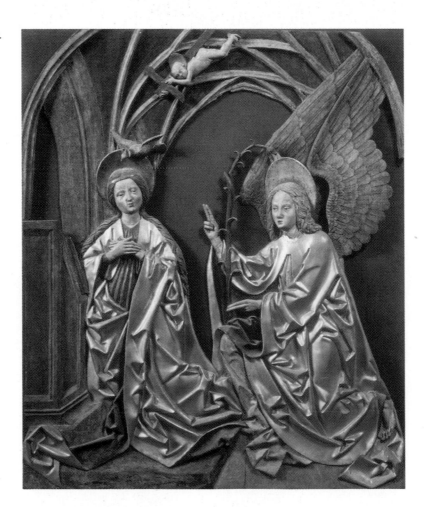

B Jeff Koons. *Flowering Puppy.* 1992. Live flowering plants, earth, wood, steel. 14.4 × 8.3 × 9.1 m installation view. "Made for Arolsen." Schloss Arolsen, Germany, 1992.

Architecture throughout history has employed multicolored surfaces, celebrating the potent combination of color and form. From painted tribal dwellings fashioned from animal hide and branches, to cathedral mosaics, color and architecture have worked in unison.

Greek temples, as we know, stand austerely white in the hot Athens sun. This view has contributed to our understanding of Greek culture and has influenced countless architects. Today it is believed that the Greek temples were, in fact, painted—decorated with numerous highly intense colors. Has a historical misunderstanding contributed to our contemporary notion of achromatic purity? While Modernist architects and sculptors stood in opposition to the painted/decorated surface, we can see that even they utilized more than one color per object and, furthermore, did so with great sensitivity. Frank Lloyd Wright's *Fallingwater*, 1936 **(A)** is an orchestration of warm earth colors that speak clearly of the stone, concrete, and wood that construct it, the conditions of its site, and the landscape in which these materials originated. This monochromatic color range allows subtle shifts in value and hue in concert with light and shadow to offer a surprising variety of chromatic events.

Upon close examination, even the most severe steel and glass skyscraper reveals an array of color, however natural and true to its materials—warm and cool greys of concrete and stone, painted steel, and aluminum on the exterior; marble, wood, painted Sheetrock, and accents of brightly colored modern furniture inside. In spite of the analogous or monochromatic environment, we acknowledge that a symphony of subtly different colors is at play and that it is impossible to escape the polychrome.

Postmodern architecture (architecture since approximately 1960) renewed interest in strong color statements and polychromatic decoration. Postmodern architects feel free to appropriate styles from the past, utilize new materials, and pay homage to vernacular forms. In short, they just want to have fun. Dutch architectural firm MVRDV's housing development in Amsterdam **(B)** cantilevers huge wood boxes off an ordinary façade and then again with great flair projects transparent balconies. With a savvy color sensibility and a highly developed sense of humor, MVRDV utilizes the traditional warmth of wood (low-intensity orange) and intense purples, greens, and oranges to dramatize each element of their spectacular projecting geometric forms.

A *Fallingwater.* Frank Lloyd Wright, architect. 1936. © Jan Moline/Photo Researchers, Inc.

B MVRDV WoZoCo Amsterdam. Cantilevered Apartments. Photo Hans Werlemann/MVRDV.

Almost everything in the contemporary world is designed. From milk cartons to jet airplanes, product designers were present at the inception, making drawings, prototypes, or computer-aided studies. Color plays a significant role in making products that function well and look great. Medical equipment is color-coded to prevent dangerous errors, sports equipment in highly visible fluorescent colors prevents accidents or aids in retrieval, and lighting design promotes healthy vision and creates safe workplaces.

The automobile is perhaps the most familiar designed product of the twentieth century. Cars are not just modes of transportation we take for granted but are objects of affection. Since the post-WWII years, the automobile has grown exponentially in number and variety. Color has played an important role in its allure.

Functionality comes first in automotive product design—paint is a skin that prevents rust and prolongs the life of steel. If this were all paint did, we would still be riding in basic Model T Ford black. Automobile designers have fashioned chrome, steel, and color into contemporary icons, objects of desire. From faux wood-sided station wagons to candy-colored metal-flaked hotrods, cars are among the most vivid contemporary expressions of color.

Cars are also one of the many products that juxtapose inside and outside. A powder-blue 1952 Packard convertible coupe with a red leather interior **(A)** displays public and private space—a flowing blue steel shell designed to slice through air and a red-and-white interior space that cradles the user in leather.

A 1952 Packard 250. Convertible Coupe. *Collectible Automobile.* August 2002, 47. © Publications International, Ltd.

Joys of Spring

Of the ten thousand trees
on the river banks, the apricot trees

have just started to blossom
in the wind of a night.

Of the whole park,
dark and pale colors

are mirrored
In the bright blue waves.

—Wang Wei*

Few sights are more spectacular than flowering fruit trees in the spring. In a few days, an entire cherry grove blossoms, dazzling our vision with pink. Later, as the petals fall, great circular pink fields appear on the lawn. This is one of nature's annual kinetic spectacles.

Kinetic light sculpture, theater, light shows, and fireworks displays all structure light in choreographed sequences that utilize time (and often sound) as elements. Cinema also deals with light, sound, time, and motion *plus* image, dialogue, and narrative. Filmmaker Peter Greenaway was trained as a painter. In his film *The Cook, the Thief, His Wife and Her Lover* **(A)** many scenes are monochromatic compositions, successively flooding the retina with pink, then red, then white. When a character in one room walks to another room, her clothing miraculously changes to match the color of the scene. In the restaurant's red dining room, she wears red; when she enters the white bathroom, her dress is white. It is as though she walks from one painting into another. This impossibility has an internal logic, it maintains the monochrome format, and subliminally it takes us into the visual language of dreams. Color and duration together set a mood and support the intent of the filmmaker. Color and duration also create structures that delight us with panoramic displays.

The effects of contemporary theater lighting are impressive **(B).** Thanks to computerized systems, a stage's darkness can be penetrated by a single thin beam of descending ruby light and then by many beams. This linear field can gradually transform itself into an entire stage flooded in orange light, then instantly turn green, and then slowly fade. This reminds us of the powerful influence of various light sources on surface color. What we see is always the result of mutual influence.

A *The Cook, the Thief, His Wife and Her Lover.* Film by Peter Greenaway. © Close Murray/ CORBIS Sygma.

* Wang Wei, "Joys of Spring," *Twenty Short Chinese Quatrains of the T'ang Period* (Florence: Sansoni, 1954), p. 21.

B The New York City Opera production of *Moses und Aron*. Photo credit © Carol Rosegg.

In 1980 the Whitney Museum of American Art mounted an exhibition of James Turrell's work. As visitors exited the museum's elevator and stepped into the exhibition space, they found themselves facing a wall and a grey rectangle. The grey rectangle appeared to be a minimal monochrome painting, until, perhaps, one of the two women standing next to the piece leaned over and stuck her head into it! This installation actually consisted of a rectangular hole cut into the wall; the room-sized shape within was simply in shadow. This was no ordinary hole. Its edges were beveled sharply so no light-catching wall thickness would be apparent. A blunt edge would have provided the visual cue needed to interpret the piece as just a windowlike opening in a wall. The lack of cues allowed the spatial nature of this piece to remain ambiguous. Even after the museum visitors realized they were simply looking into a void, the shadow-rectangle clung to the surface of the wall or hovered in air. All this magic came from so little—just ambient light and shadow.

These early Turrell pieces utilized natural light, but in his later work he employed artificial light in various hues. The installation in **A,** *Night Passage,* 1987, utilizes fluorescent and tungsten lamps, creating a blue glow from the void behind a rectangular hole cut in the wall. The space within is energized and made palpable.

One of the interesting things about Turrell's exhibit at the Whitney was the fact that there was an Edward Hopper show installed at the same time. This was a great curatorial decision. Hopper paints light and space in a completely deadpan American way, stripped down to bare essentials. Here were two artists, two generations apart, taking on the enormous challenges of primary phenomena. Both reductive, but two drastically different approaches—one virtual, the other "real," one two-dimensional, the other three-dimensional.

Hopper's 1961 painting, *A Woman in the Sun* **(B),** depicts a spartan interior space with a horizontal sliver of yellow. This long, yellow rectangle is an abstract shape in a geometric composition, but it is also "effortlessly" sunlight on the floor. The rightness of the color of the light in relationship to the surrounding colors convinces us that paint here is actual light. The luminous curtain on the right is a brilliant touch that shows us the source of the light, and we can almost feel the breeze. As in Turrell's work, it is light that gives shape to space, and it is light and space that are intangible subjects of wonder.

B Edward Hopper. *A Woman in the Sun.* 1961. Oil on canvas. $40^{1}/_{8}''$ × $61^{1}/_{4}''$. Whitney Museum of American Art, New York; 50th Anniversary gift of Mr. and Mrs. Albert Hackett in honor of Edith and Lloyd Goodrich. 84.31.

A James Turrell. *Night Passage.* 1987. Rectangular cut in partition wall, fluorescent and tungsten lamps, and fixtures. Dimensions vary with installation. Solomon R. Guggenheim Museum, New York. Panza Collection, Gift, 1991, 91.4080. Photo © Giorgio Colombo, Milano. © The Solomon R. Guggenhcim Foundation, New York.

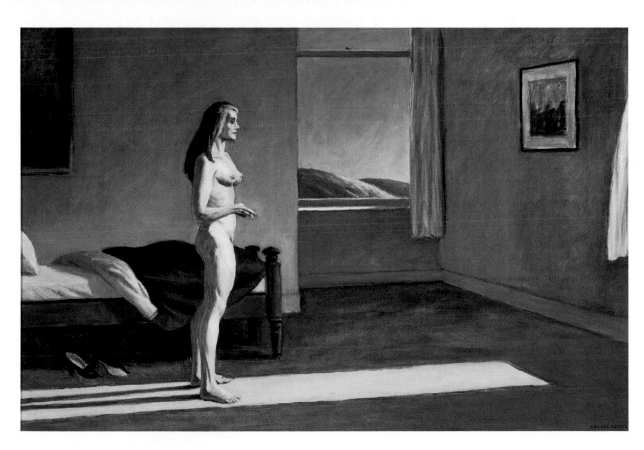

French Impressionist painter Claude Monet has taught us important lessons on the interdependence of light and form (see Chapter 1, page 15). His well-known studies of *Rouen Cathedral* at different times of day make the important point that there is no Rouen Cathedral without light. Every stone, corner, edge, and surface looks the way it looks because of light—its temperature, angle, and the atmosphere it passes through. Monet is really painting light in this series. Rouen Cathedral is just a vehicle that allows him to hold and study light's ephemeral transformations.

The photograph of larva of the eyed hawk-moth **(A)** clearly displays the intimate relationship of light and form. The illustration shows the caterpillar in its normal position, as it is usually found in its natural surroundings. It appears to be a flat leaf and is protected from predators. This is an excellent example of reverse or counter shading, which is one of the most common methods of disguising form in nature. The sun illuminates from above; form is detected by shadow below. If an animal or insect's coloration is dark on top and light below, its form will seem to disappear. Many deer, dogs, birds, fish, and insects, as well as military aircraft, utilize form-erasing counter shading.

Pure white architecture and interior spaces may be devoid of surface color and seem dull and uneventful, but when plain, white structure is done right, as in Richard Meier's Swissair building in Melville, New York **(B),** it becomes the perfect foil for capturing the play of warm light and cool shadow as they move across and around form. It also allows the form to be revealed and to reveal different aspects of itself in different light conditions from dawn to dusk, summer to winter, echoing the insights of Monet's studies of *Rouen Cathedral.*

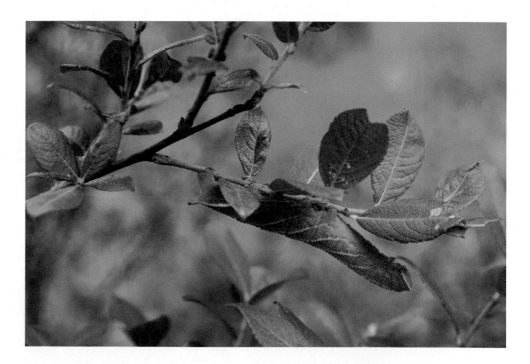

A Larva of Eyed Hawk-Moth. © Heather Angel/Natural Visions.

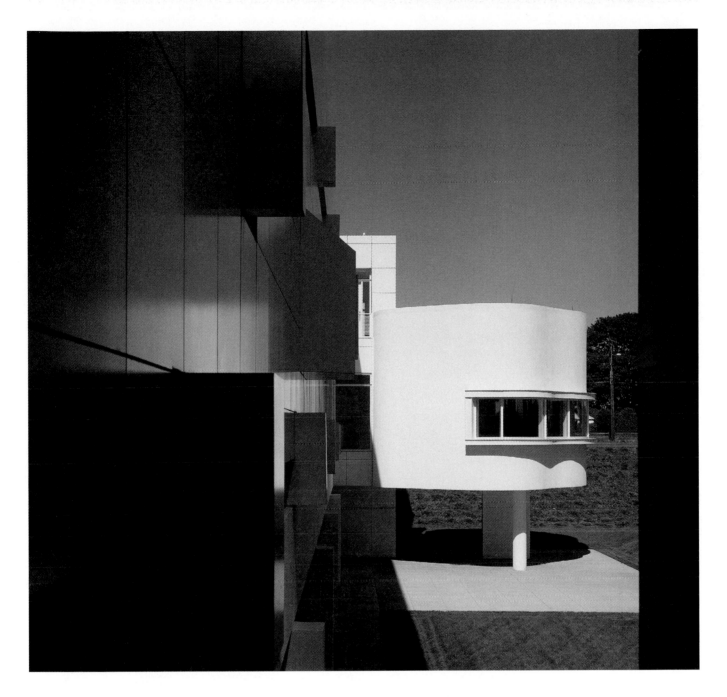

B Swissair North American Headquarters. Richard Meier, Architect. Melville, New York. 1991–1995. © Scott Frances/Esto.

Transparent materials allow light to pass directly through them; distinct images are visible, whether the material is clear or colored. Translucent materials transmit and diffuse light but have a degree of opacity that does not allow clear visibility through the form.

From stained glass, such as the windows of Marc Chagall (see Chapter 4, page 95), to modern glass-and-steel skyscrapers, transparent/translucent color continues to play a vital role in the arts, design, and architecture. Finnish designer Timo Sarpaneva's functional glassware **(A)** illustrates the power of transparent color to transform simple shapes into transcendent form. The natural thickening and thinning of the glass walls allow the blues, greens, and greys to modulate in intensity.

Clear glass is undoubtedly one of the most important contemporary building materials. How amazing it is that such a substantial and rigid material could be completely invisible! While clear glass is itself colorless, those who appreciate the chromatic realm owe it an enormous debt. Glass enables us to be surrounded by vistas. The entire color universe comes rushing in—sky and clouds, the neon light on the corner, the house across the street, trees, flowers, birds, butterflies, the ocean's changing horizon, the sky at night.

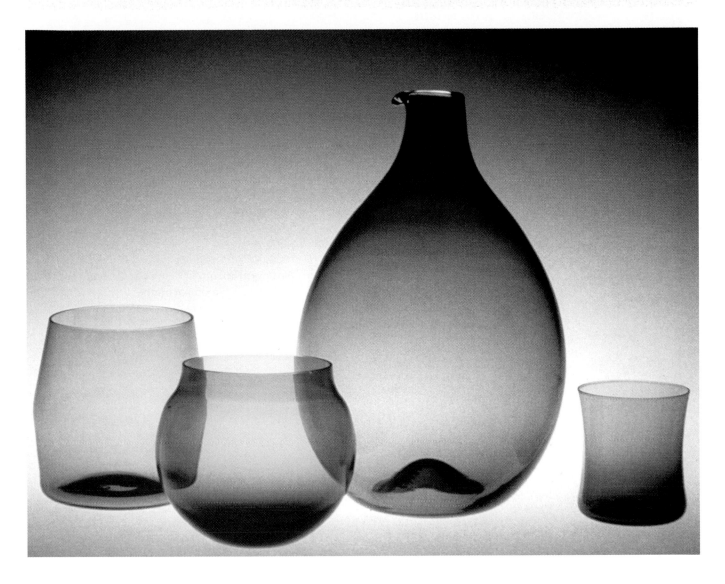

A Timo Sarpaneva. *I-Glass Series.* Courtesy of The Finnish Glass Museum.

Reflective surfaces are determined by qualities of texture—the smoother the surface, the more it reflects. A matte or pebbled surface will scatter and absorb most of the light waves that strike it, creating a diffuse light, while a smooth surface will reflect almost all of the light directly back. Especially smooth, polished surfaces, like glass, bounce light back in such an orderly manner that we are able to see reflected images. Pedestrians are reflected in store windows and their color is altered as they pass rear-painted windows. When smooth surfaces deviate from the planar, taking on three-dimensional form, they reflect light in fascinating ways and may reflect distorted images.

Artists, designers, and architects have long explored the effects of reflective surfaces. Architecture of buffed and polished metals, dark and clear glass, and variously colored mirrored surfaces has become ubiquitous in the contemporary landscape. James Carpenter's Dichroic coated-glass panels amplify changing colors and patterns of light in the Munich airport **(A)**.

Reflections are inherently kinetic. Light passes over a surface and its moving trajectory is reflected back to us, clouds float by on the surface of the mirrored glass office building, and the building darkens as the clouds pass over the sun. When we walk by the chromed exhaust pipes of a new Harley, the colors splinter and undulate on the surface. Drive it into the sunset and watch the chrome shift from orange to red and then explode white as passing headlights catch the pipes.

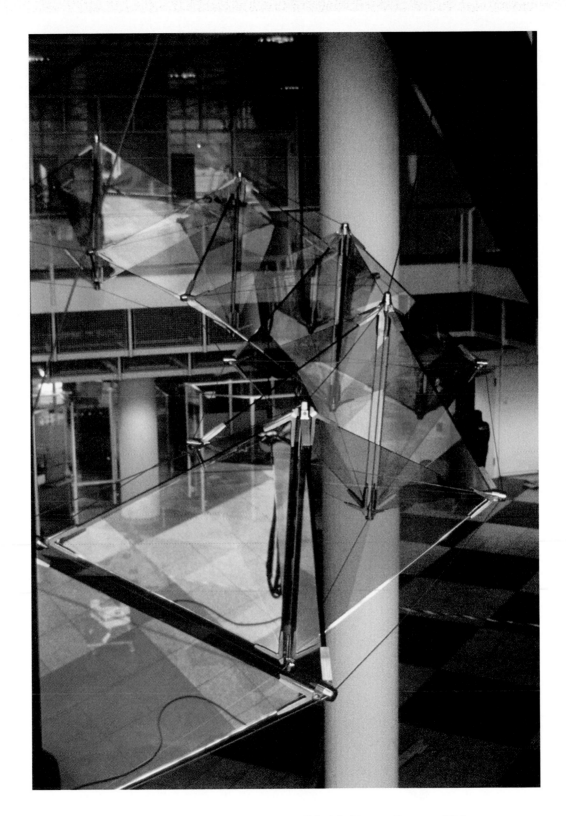

A James Carpenter. *Refractive Tensegrity Rings.* 1993. Munich Airport, Germany, 1993.
Commissioned by BMW Ag, Germany. Dichroic Coated-Glass Panels and Stainless-Steel Fittings,
22′ (7m) diameter. Courtesy of James Carpenter Design Associates.

Things that radiate or reflect light are luminous. Painting and photography deal often with creating the illusion of luminosity. Here we will consider actual luminosity.

In the evening the windows of houses and buildings glow with warm incandescent or cool fluorescent light. The modern metropolis is a museum of luminosity—bright store windows, lighted signs, mammoth LED (light emitting diode) screens, and huge video monitors. Times Square **(A),** with the U.S. Armed Forces Recruiting Station in the foreground, is resplendent with back-lit kinetic signs, neon lights, and automobiles. Las Vegas is another luminous city, an oasis of over-the-top neon signs.

Designer Karim Rashid's *Globject* **(B)** probably doesn't do a great job of lighting a workbench, but it *is* a kind of wonderful and magical, luminous pet rock.

Aside from fire and the glow of hot filaments and molten metal, there are a number of different types of luminosity. Neon gas sealed in glass tubes glows red-orange when an electrical current passes through the gas (other gases produce different colors). Fluorescent bulbs with internal coatings of phosphors emit light after absorbing ultraviolet radiation generated by passing electricity. Fluorescent paints absorb ultraviolet energy from the sun and emit small amounts of colored light. The most important fluorescing object of the twentieth century is undoubtedly the television screen. It has replaced the original luminescent gathering place, the hearth.

When a surface appears to shimmer and change color as it moves or as you move around it, it is called **iridescent.** Iridescence occurs in soap bubbles, films of oil on water, the feathers of many birds from hummingbirds to peacocks, butterflies, beetles, and many insects. The brilliant colors of iridescence are not created by pigment. Iridescence is caused by the refraction, diffraction, and interference of wavelengths of light. For example, some beetles have wings containing numerous transparent facets that create altered light patterns, resulting in an array of shifting spectral colors.

B Karim Rashid, Inc. *Globject.* Electro luminescent sheet, soft polyurethane resin, and cables. Special edition for 1999. Courtesy of Karim Rashid, Inc.

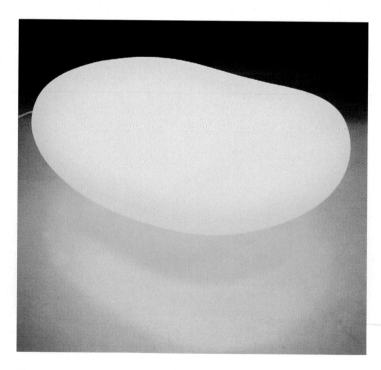

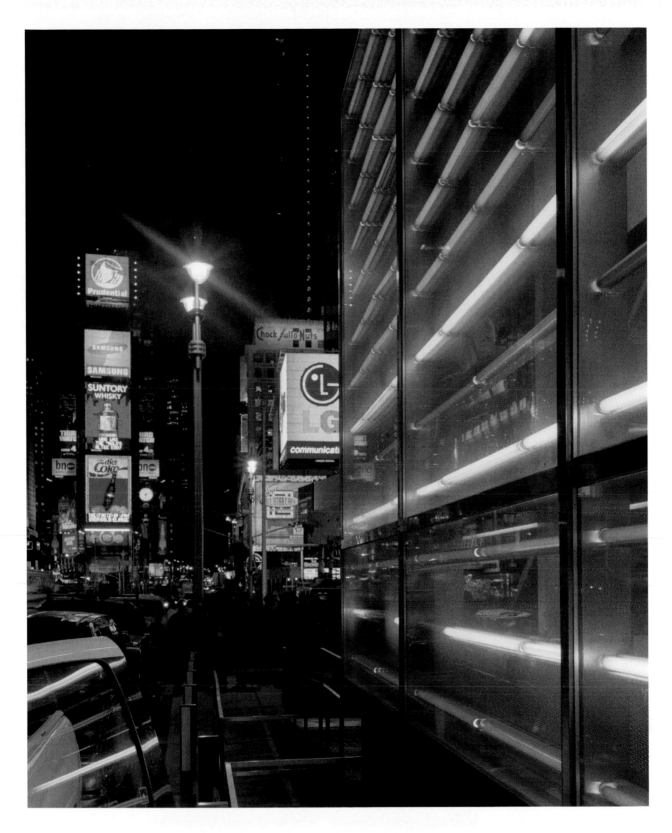

A U.S. Armed Forces Recruiting Station. Times Square, New York. 1999. Photographer David Joseph.

Unity in color is achieved in many ways, but first and foremost it is accomplished by the monochromatic color scheme. Color structures consisting of subtle variations of a single color are extremely common. Suprematist abstract painter Kazimir Malevich became famous for his geometric paintings consisting of white squares on slightly different white grounds. From Malevich to Ad Rinehardt, the monochromatic painting showed us how to slow down perception and perceive subtle shifts and nuances. Some artists dedicated to the severity of the monochromatic palette pioneered an even more spartan practice, that of painting a single color on a single panel—**monochrome painting.** In terms of unity, monochrome painting is perhaps the final word. Rudolf Stingel's 1991 installation at the Daniel Newburg Gallery in New York **(A)** consisted of nothing but brand-new intense orange wall-to-wall carpeting. This piece is either a homage to, or a sly critique of, the monochrome; nevertheless, it is also a pop installation and a no-holds-barred celebration of orange.

Analogous colors also facilitate the creation of color unity. In contrast to traditional single-color china tableware, *Chromatics* **(B)** was carefully designed to energize a table with a variety of colors. As result of its blue-green color scheme, a fair degree of unity is achieved.

Complementary colors also promote unity. The Versace outfit in **C** might appear to be out of control with multicolored stripes, numerous solid colors, and yellow shoes that function as flamboyant accents. It is, in fact, unified by its near complementary orange-red and blue-green motif.

One of the most enduring of all design principles is "unity with variety." So many wonderful things in both two and three dimensions, whether designed or found in nature, manifest these dual traits. Portia Munson's *Pink Project* (see Chapter 6, page 155) is an excellent example of unity with variety. *Pink Project's* unifying color scheme allows for a wide variety of disparate forms without appearing chaotic, balancing order and disarray.

C Versus Versace ad. Inside front cover. *Wallpaper.* May 2002, p. 1.

A Rudolf Stingel. *Installation.* 1991. Daniel Newburg Gallery, New York. Courtesy Paula Cooper Gallery, New York.

B "Chromatics" place settings, American, 1970. Gerald Gulotta, shape designer; Jack Prince, pattern designer. Block China Company, New York, importer. Tableware: porcelain, printed; placement: linen, dyed, woven; flatware: stainless steel. Dallas Museum of Art, gift of Gerald Gulotta.

Order is of the utmost importance to artists, musicians, architects, designers, and scientists. While painters have long used color to organize their pictorial structures, we find color used to "order" the world everywhere around us: Doctors' offices use color-coded stickers to differentiate folders in their files; charts, graphs, and maps use color to give order to information. The Danish traffic sign specifications in **A** display the organizing logic of a coding system that attempts to find distinct and legible color combinations for all traffic sign categories. The legend provides such information as, "Ring routes with black circle in front of black number. The background is yellow for primary routes, white for secondary routes. Paths on national routes with red background and white number, on other routes blue background and white number." Illustration **B** offers another example. The circa 1900 Macklin Bible was systematically color-coded by its owner, Alfred Woods, as a visual study guide that might reveal patterns otherwise obscure.

To order and to find order are fundamental to the intellectual process. We might arrange our closet by putting all shirts in one group and all jackets in another, and so forth, or we might hang all garments by color—red here, blue there. Perhaps we could group our clothes by the activities they are used for—work clothes versus sports clothes; perhaps we might use a combination of many systems; or perhaps we have no system—but even such disorder might be thought of as a random system.

Writer Jorge Luis Borges exposes the potential for arbitrary ordering and classification systems in this fictional list attributed to a certain Chinese encyclopedia: "animals are divided into (a) those that belong to the Emperor, (b) embalmed ones, (c) those that are trained, (d) suckling pigs, (e) mermaids, (f) fabulous ones, (g) stray dogs, (h) those that are included in this classification, (i) those that tremble as if they were mad, (j) innumerable ones, (k) those drawn with a very fine camel's hair brush, (l) others, (m) those that have just broken a flower vase, (n) those that resemble flies from a distance."*

We live with so many ordering structures—the periodic table of the elements, biological classification, national boundaries, and racial categories in which the slightest variation in skin color can have serious social consequences. Categories are never neutral. Fortunately, ordering systems are constantly being reevaluated and reconfigured.

Ideas concerning order, as practiced by photographers, painters, architects, designers, and craftspeople, are also changing as interests shift and new media emerge. Nonetheless, it is safe to say that ordering form, color, and material, in general, is the primary activity of almost every visual practitioner and involves the utilization of most of the topics discussed in *Color Basics*. To make an object or a painting is always to determine the order of a long list of attributes—hue, value, intensity, size, shape, texture, and so on. To compose is to order.

A Route Directions. "Design of the Danish Traffic Signs" by Jens Bernsen, Kai Christansen, Ib Møller. Dansk Design Center, 1996. Courtesy Danish Road Directorate.

Europaveje. European routes.	E20	Grøn bund, hvidt nr. 2- eller 3-cifret tal. White number on green. 2 or 3 digits.	O 3	Sort ring og nr. Gul bund ved primære, hvid ved sekundære veje. Black circle and number. Yellow background for primary, white for secondary roads.	Ringruter. Ring routes.
Primære ruter. Primary routes.	15ø	Gul bund, sort nr. 1- eller 2-cifret tal. Black number on yellow. 1 or 2 digits.	3	Rød bund og hvidt nr. White number on red.	Nationale stiruter. National path system.
Sekundære ruter. Secondary routes.	453	Hvid bund, sort nr. 3-cifret tal. Black number on white. 3 digits.	41	Blå bund og hvide tal. White number on blue.	Andre stiruter. Other paths.

* Jorge Luis Borges, "The Analytical Language of John Wilkins" in *Other Inquisitions 1937–1952* (Austin, TX: University of Texas Press, 1964).

of them.

2 And on the feventh day God ended his work which he had made; and he refted on the feventh day from all his work which he had made.

3 And God bleffed the fe-venth day, and fanctified it: becaufe that in it he had refted from all his work which God created and made.

How to Study the Bible.

THE LANGUAGE OF COLOUR.

1	YELLOW.	God Speaking.
2	BLUE.	Good. Honest.
3	GREEN.	Bad. Evil.
4	RED.	Notice or Key of the Subject.
5	VIOLET.	Name of Place.
6	VERMILLION.	Gentiles. Nations.
7	BROWN.	Quotations in the New Testament from the Old Testament.
8	BLACK.	Devil. Sin.

ALFRED WOODS,
INGATE LODGE, BECCLES.

B From *2002 Redstone Diary: Colour 2002.*
Courtesy David Batterham.

A religious community that originated in England in the middle of the eighteenth century, the Shakers arrived in the United States in 1774. Advocating a strict and simple way of life, their design and architecture displayed a devotion to order that embodies religious beliefs. Order, functionality, and a disdain for decoration are hallmarks of Shaker products **(A).** A Shaker maxim states, "In building a house, or constructing any machine, each part naturally lies in apparent confusion till the artist brings them together, and puts each one in its proper place; then the beauty of the machinery and the wisdom of the artist are apparent."

In this Shaker community, every single bed was painted the same green (a traditional Shaker deep green-black, also known as bottle-green). We imagine the residents could sleep more soundly knowing that all like objects, though out of sight in neighbors' houses, were painted the very same color.

To *order* implies an operative principle. What is the end our ordering seeks? For the Shakers it was a way to simulate the perfection of heaven here on Earth.

A Interior, Meeting House. Hancock Shaker Village, Pittsfield, MA. Photograph by Michael Fredericks.

Utility plays an enormous role in color use—from nature's insistence that every shape and every color serve a purpose to the demand for functionality in the built world. The universal need to survive determines protective coloration for multitudes of living things, and it requires that designers employ such safety features as highly visible red handrails in factories and on dangerous machinery **(A)**. Order, too, is a kind of utility. We are protected if we know that all moving parts of a machine are painted one color and all parts that get hot are painted another. Examples of safety provisions through the use of color in the built environment are ubiquitous: yellow edges on steps in industrial buildings, red warning stripes on dangerous low overhangs, red stop signs, and flashing yellow lights. The knobs on medical equipment, industrial control panels, and office products may be of a different color to make clear their different functions, even when the user is under stress.

Interface design is a field that deals with the creation of clear and logical user–machine interfaces. As the use of computers and computerized devices grows, interface design has become an increasingly important field of practice. The Zelco calculator **(B)** is a good example of color at the service of utility and usability. Not only are its key functions color-coded in distinct groups, but many of the buttons are of a different size and shape to make different operations clear through redundancy. The Zelco calculator's color-coded control panel communicates by emphasis.

In the field of visual communication, an important requirement of typographical design is legibility. Legibility is proportionally urgent in relationship to the importance of the information being presented. A stop sign consisting of small pink cursive letters on a field of beige that is equal in value to the pink would obviously be highly illegible and thus extremely dangerous. Legibility is a function of communication; it relies on visibility, not **camouflage.**

Color is also a sign of various organic conditions—the ripeness of fruit, the rotting of meat; red rashes, infections; and the paleness of anemia. We determine the sweetness of chocolate milk (as well as the taste of many other foods) by simply observing its color **(C)**. In the same way, color is used as a benchmark in science and industry. The Macbeth Company sells products that facilitate the precise control of color by providing accurate and uniform standards, from Munsell Color Systems to color-blindness tests. Like litmus paper and other color-based tests in the health field, this "PurTest" envelope **(D)** gives instructions for testing the nitrite/nitrate level of drinking water by comparing the enclosed test strips to the colors on the envelope.

C Glass of chocolate milk.
© Photopia.

B Phorm Ergonomic Hand-Held
Calculator, U.S.A., 1986.
Designed by Donald Booty, Jr.
(b. 1956). Distributed by Zelco
Industries. Plastic and acrylic
housing. Cooper-Hewitt, National
Design Museum, Smithsonian
Institution. Gift of Arango Design
Foundation and Steelcase Design
Partnership, 1994-31-6. Photo:
Dave King.

D PurTest® Envelope. PurTest® Nitrate/Nitrite
Water Test Strips color chart provided by
American Water Service, Matthews, NC.
© Copyright American Water Service.

A Crane at the Aciere Solmer steel complex at Fos-sur-mer
near Marseilles, 1976. Courtesy Jean Philippe Lenclos.

Emphasis is perhaps one of the most basic and delightful uses of color. The red door on a white house employs simple value difference as well as intense hue to lead us to the entrance. Fruit turns from protective green to intense red, orange, and yellow when ripe and seeds are ready for dispersal. When the hue changes, the fruit is emphasized and its ripeness made apparent.

Sculptor Alexander Calder has consistently used color to attract viewers to various parts of his playful constructions. He takes a topologist's delight in teaching us, through strategic color application, that ends of forms are different than interiors and that edges are different than ends. In *Myxomatose,* 1953 **(A),** he uses just three colors in this earthbound mobile. Calder directs our attention to the large disk by painting it bright red, and to the smallest disk (upper left) by making it blue. Though disparate in size, the red and blue disks are united by color. Calder stresses the importance of these two elements, capable of balancing, visually and literally, the numerous black disks.

Product semantics is a field of design that promotes the concept that objects should communicate their purpose to the user. The handle on Michael Graves's teapot **(B)** says, "Pick me up, grab here." It offers itself to the user in a larger than life gesture and is highlighted with color. Color emphasis plays an important role in communicating proper use of products.

B Michael Graves. *Alessi Tea Kettle.* Photograph by George Kopp.

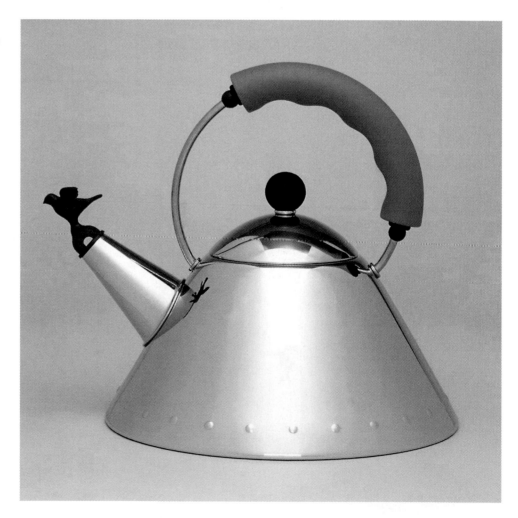

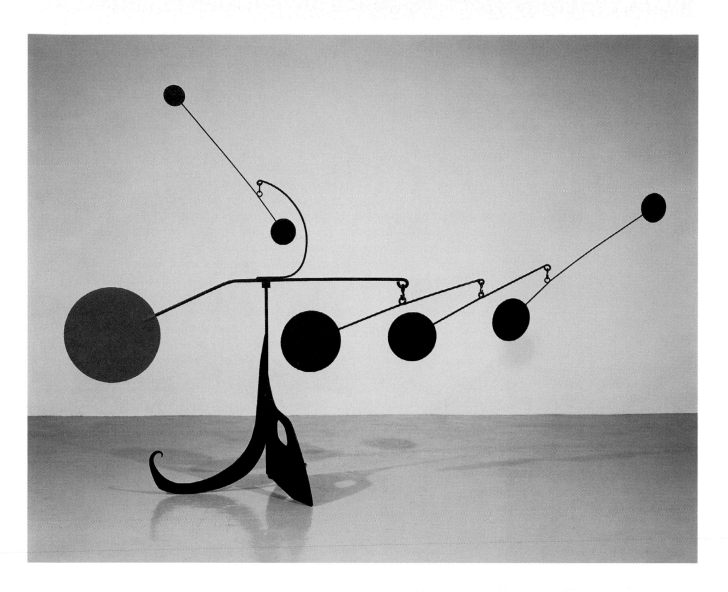

A Alexander Calder. *Myxomatose.* 1953. Sheet Metal, Rod, Wire, and Paint. 101″ × 161″. Copyright Art Resource, NY. © 2003 Estate of Alexander Calder/Artists Rights Society (ARS), New York.

Proportion is the comparative relationship between things and especially refers to size, quantity, and magnitude. Proportion is often expressed as a ratio. In the realm of color, proportion is an important factor.

Two colors of equal size might appear lifeless when **juxtaposed** (placed next to each other) as two rectangles, while the same two colors presented with one area extremely large and the other as small dots, for example, might appear very active. When juxtaposing color, we can never think of color isolated or in the abstract. We must constantly observe color in context, asking always, "What do these colors do to each other in this situation? In these shapes? In this placement? In these proportions?"

Proportion also plays an important role in matters concerning harmony and discord. It is a well-known fact that two colors considered discordant when juxtaposed in one proportional relationship may be considered harmonious in another. Proportion also suggests balance metaphorically, in that those with a good sense of proportion maintain a proper relationship between things or parts.

Balance is also related to proportion. While forms of equal size might imply balance, when color comes into play, we may often see large light or dull areas balanced by small dark or intense shapes.

In the first-floor gallery of the American Folk Art Museum designed by Tod Williams and Billie Tsien **(A),** Italian limestone, concrete, green fiberglass, and a cherry bench are brought together in a restrained composition of varying shapes, colors, and proportions. A large translucent green fiberglass wall hovers above a low-slung dash of cherry bench. While quietly delightful in its own right, this space respects its task of displaying art works.

A Atrium, American Folk Art Museum, architects Tod Williams and Billie Tsien. © Michael Moran.

Chapter 6
COLOR IN NATURE AND CULTURE

In spite of the proliferation of human-made artifacts and the built environment, nature reigns supreme as our wellspring, both physically and mythologically. We are in nature and of nature. When painter Hans Hofmann suggested that Jackson Pollock work more from nature, Pollock replied, "I am nature." Pollock's iconoclastic response points to the contemporary notion that nature and culture are one. Though we frequently look back at nature to study its unique lessons, and look forward to culture to attempt to unravel its influence, we just as often conflate the two. Not only do we study and celebrate nature through our depictions of it (painting, sculpture, photography, film, and so on), but we also explore it through shaping it directly: in gardening, flower arranging, bonsai growing, the breeding of plants and animals, farming, and cooking **(A),** as well as in the fields of fashion and cosmetics.

The feathers of the male bower bird, *Ptilonorhynchus violaceus,* have a blue sheen. The bower bird decorates its raised nest (bower) with blue flowers and blue objects, such as plastic toy parts, stones, and paper. It is a relentless collector of all things blue, an interior decorator aiming to attract a mate **(B).**

The boundaries between nature and culture blur as well when we look at human involvement with nature. The age-old breeding of plants and animals in order to develop new forms and colors to delight and entertain is a major industry. Human intervention in nature has produced Japanese carp of astounding variety, as well as dogs as different as greyhounds and beagles, and a deluge of new varieties of plants and flowers. Nature constructs us, and we construct nature.

B Bowerbird in Nest. © Staffen Widstrand/CORBIS.

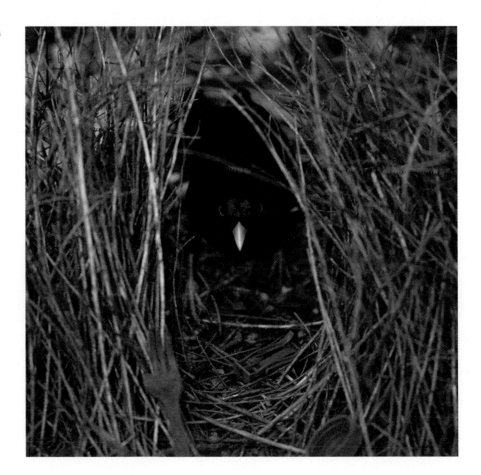

A Remy Funfrock's Chocolate Peach Tart with Apricot Green Tea Ganache and Vanilla Ice Cream. *Pastry Art and Design,* 7, no. 3 (2002). Photo copyright © 2002 by John Uher.

Camouflage, while still utilized in contemporary life, has roots deep in the natural world. The basic principle of camouflage is, of course, to conceal. An object that exists within one's field of vision may remain invisible due to the visual similarity of the object to its environment. For us the most common kind of camouflage is this "hiding in plain sight" variety—for example, the green or brown leaflike pattern that allows the soldier or the tank to blend into the forest.

However, there are actually many other types of camouflage found in nature. Consider the fascinating little spider **(A).** It makes no attempt to hide itself from birds that would find it a tender morsel. In fact, this black and white spider lounges about on top of green leaves, seeming to dare predators to pick it off. What protects this spider is the fact that it resembles bird droppings. The spider remains perfectly visible, but it is simply not desirable. It is camouflaged, not in the standard sense, yet it is protected nonetheless by nature's cunning. This spider's verisimilitude is an act of double trickery. It preys on the insects attracted to the salts in bird droppings and so serves as its own bait.

The military has long used camouflage to protect troops and equipment through the utilization of cunning patterns that blend into specific environments. It has also painted airplanes to match the landscape patterns below and disguised factories to look like suburban housing developments.

Camouflage in nature contains numerous lessons for artists and designers. We pay homage to its ability to mimic almost anything, from the butterfly that carries the "picture" of its complete body prominently reversed on the rear end of its wings **(B),** to the plants that mimic the look and smell of dead meat to attract and prey on flies. Camouflage in nature teaches us about the significance of context, and it inspires us with its endless invention.

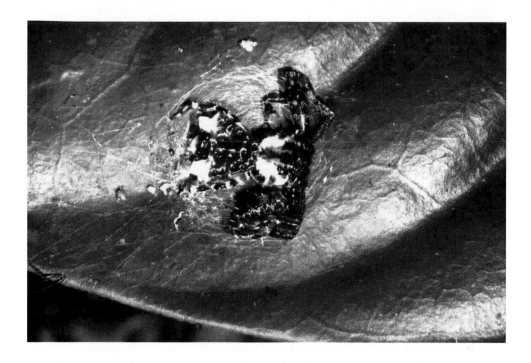

A Bird Dropping Spider. *Thomisidae Phrynarachne*, Malaysia. © Chin Fah Shin.

B Malaysian Back to Front Butterfly. *Jamides* species. © Chin Fah Shin.

Color often serves as a warning. The turbellarian worm from Malaysia displays a bold banded pattern of red, yellow, and black. Because it is easily recognized, predators that have experienced its vile taste will have no trouble avoiding turbellarians in the future. There are numerous examples of warning color in nature. The black and orange markings of the South American Poison Arrow Frog **(A)** warn of its toxic skin secretions. The red, yellow, and black assassin bug from Borneo spits poison saliva. A number of insects actually *mimic* the black and yellow warning stripes of wasps so as to deter predators, though they are themselves benign, stingerless creatures.

The military has painted ships and airplanes with dazzle patterns (bold geometric markings that contradict the form of the equipment) to disorient the enemy and confound spatial perception. War paint and uniforms are also often used as warning displays. Artists, designers, and architects as well have utilized disorienting patterns. Instead of the usual use of color to complement and emphasize form, some have found it more useful for surface color to contradict form.

Color is also used for display. In nature, numerous animals engage in courtship display. The peacock is perhaps the most familiar example. The peacock spreads and quivers its brilliant blue, green, and gold iridescent tail feathers in its elaborate courtship display. Flowers use every combination of form and color to attract the pollinating creatures they depend on for survival.

On some level, many works of art and architecture are displays. Such work utilizes color to attract or dazzle viewers who in turn might linger to have other experiences.

Clothing, jewelry, tattoos, and cosmetics are also displays employed to flaunt one's personal style. It should be noted that these customs are not those of obscure subcultures but support major industries dedicated to satisfying mass desire. This page from *Vogue* magazine **(B)** is a good indication of the serious relationship between cosmetic color and ideal beauty. Is it surprising that color and sexual reproduction are linked in human social behavior as well as in nature at large **(C)?**

A Poison Arrow Frog from South America. © Heather Angel/Natural Visions.

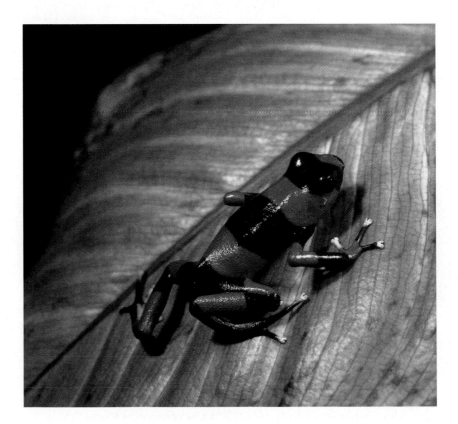

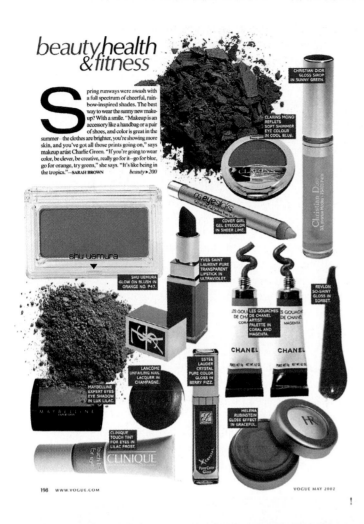

B *Vogue.* May 2002. Page 198.
Copyright © 2002 Conde Nast.

C Female Guppy (left), Male Guppy (right). © Dr. Paul A. Zahl/Photo Researchers.

Nature has always been our primary model. We stand before its grand scale, spectacle, and endless diversity, awestruck and humbled. Albert Pinkham Ryder clearly articulated the daunting task faced by representational painters in this passionately told tale:

> Nature is a teacher who never deceives. When I grew weary with the futile struggle to imitate the canvases of the past, I went out into the fields, determined to serve nature as faithfully as I had served art. In my desire to be accurate I became lost in a maze of detail. Try as I would, my colors were not those of nature. My leaves were infinitely below the standard of a leaf, my finest strokes were coarse and crude. The old scene presented itself one day before my eyes framed in an opening between two trees. It stood out like a painted canvas—the deep blue of a midday sky—a solitary tree, brilliant with the green of early summer, a foundation of brown earth and gnarled roots. There was no detail to vex the eye. Three solid masses of form and color—sky, foliage and earth—the whole bathed in an atmosphere of golden luminosity. I threw my brushes aside; they were too small for the work in hand. I squeezed out big chunks of pure, moist color and taking my palette knife, I laid on blue, green, white and brown in great sweeping strokes. As I worked I saw that it was good and clean and strong. I saw nature springing into life upon my dead canvas. It was better than nature, for it was vibrating with the thrill of a new creation. Exultantly I painted until the sun sank below the horizon, then I raced around the fields like a colt let loose, and literally bellowed for joy.*

Ryder touches on many important issues in this anecdote. He reminds us of the impossibility of representation (paint can never approach the luminosity and epic scale of nature), and thus the requirement that a painting must "live" by the strength of its own unique and vigorous properties of form and color.

Albert Pinkham Ryder's *Moonlit Cove* **(A)** consists of a few large simple shapes of bluegreen, black, yellow, and brown. A luminous moon and a dark cove are sensitively depicted, but so are powerful and mysterious interlocking two-dimensional forms—abstract painting was being invented here.

* Albert Pinkham Ryder, "Paragraphs from the Studio of a Recluse," in *American Art 1700–1960* ed. by John W. McCoubrey (Englewood Cliffs, NJ: Prentice Hall, 1965).

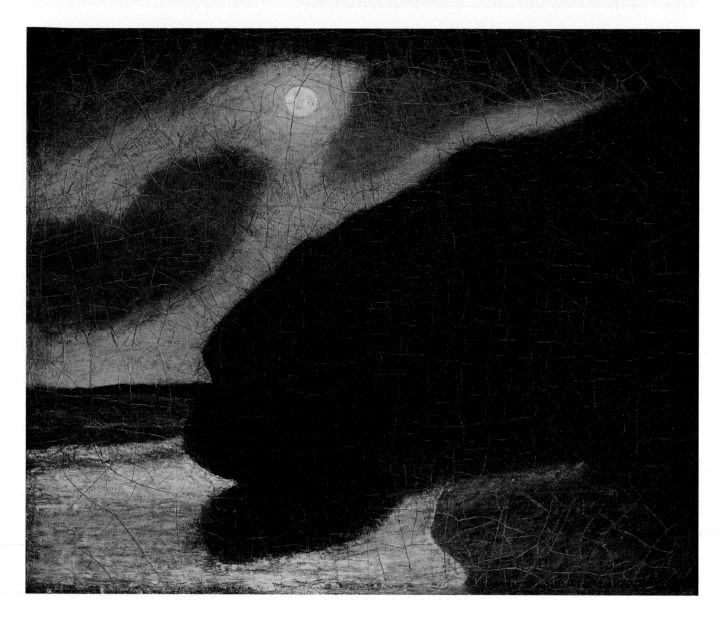

A Albert Pinkham Ryder. *Moonlit Cove.* Oil on canvas, 14$\frac{1}{8}$″ × 17$\frac{1}{8}$″. 1911. The Phillips Collection. Washington, D.C.

Monochromatic, analogous, triadic, and complementary are color schemes that have proven to be extremely useful for creating unity and harmony. Are there deep psychological or physiological reasons for deciding that certain colors "go together"? Probably not.

The study of color for students of art and design has long consisted of valuable practical exercises that enable them to see and control the formal attributes of color. In addition, we have come to appreciate the powerful influence of culture on all **aesthetic** judgments. It has been noted that when Japanese audiences heard Western classical music for the very first time, their response was laughter. As we attempt to make value judgments about color, such as "Is a particular color or color combination good or bad?", we must also be aware of cultural context and contingency. A lime green may be just the right color for the leaves of a tree in a landscape painting, or the perfect color to paint the trim in a child's bedroom, but as a lipstick color for the average consumer of cosmetics it would be shocking and garish. Custom and tradition determine a great deal of what *is* and *is not* permissible and desirable. This is not to say that we must adhere to social norms, but it is a reminder of the necessity to be aware of factors beyond the perceptual.

The inherent value of hue was critical to the ideas of Ogden Rood, an early color theorist. He believed that when pure hues are lightened or darkened, deviating from their inherent value, then placed next to different unmodified hues, the resulting pairs contradict the natural order and appear discordant or harsh.

In the early 1900s Johannes Itten, an important color theorist and teacher, outlined his ideas on harmony in his system of color. For Itten there are four types of harmonious color combinations, all determined by superimposing basic geometric shapes on the color wheel. The first combination consists of complementary pairs (dyads). The second set of relationships is determined by any three colors that form the points of an equilateral triangle when placed upon the color wheel (triads). The clearest example of this relationship is red, yellow, and blue, but orange, violet, and green also make a triad, as do many other combinations. The third combination consists of the colors determined by the corners of squares or rectangles that result in double complementary pairs (tetrads). The fourth relationship consists of hexagons, resulting in three complementary pairs. In all cases, if the selected color combinations are mixed together, they produce neutral mixtures of grey-black.

In 1839 M. E. Chevreul, director of the dye house at the Goblins tapestry works near Paris, discussed harmony in his landmark book, *The Principles of Harmony and the Contrast of Colors*. Following is a list of some of his requirements for harmonious combinations: (1) complementary pairs and split-complements (he called them "the harmony of opposites"); (2) triads; (3) the harmony of the dominant tint, such as when a painting is glazed with yellow; and (4) the simple harmony found in nature that is produced when a pure hue, its tint, and white are combined, or when a pure hue, its shade, and black, are combined. On the other hand, Josef Albers, in sync with contemporary views, reminds us that color harmonies "are not the only desirable relationship. As with tones in music, so with color—dissonance is as desirable as its opposite consonance."

Much contemporary art is iconoclastic, undermining established notions. Not unlike subcultures that subvert normalized codes, artworks may serve as acts of defiance. Fashion designer Jean Paul Gaultier flouts received notions of "proper" color **(A),** delighting us with the unexpected, and uncovering new varieties of beauty.

While formal principles of color harmony remain useful, it is safe to proclaim that no combinations are intrinsically bad. Become sensitive to the special properties of color so as to invent the combinations of color that serve your unique purpose.

A Model on catwalk, Jean Paul Gaultier show, 1995. © Photo B.V.C./CORBIS.

Portia Munson's *Pink Project* **(A)** is an excellent example of a work of art that is as much about color and form as it is about culture. It is a collection of hundreds of pink plastic objects. It is formal in that it displays a huge range of a single color—endless, subtle variations of pink—warm pink, purple pink, dull pink, hot pink. Because of the unity of color in a close range, we experience every nuanced shift in temperature and tone as if possessing heightened powers of perception. It is a stellar example of unity with variety (all pink objects in endless variations on shape and content).

Pink Project is also political, revealing a social phenomenon—pink plastic objects created for the "girl market." Despite the dwindling use of color symbolism in today's world, pink maintains its grip on products for women and girls. This is a piece that could not have been made in any other time.

Pink was once just another good workaday color, a useful red tint, but in the 1950s it became cute, fluffy, and feminine. Hot pink was the color of the decade—the color of lipstick, fashion, automobiles, houses, refrigerators, and telephones **(B).** Pink is a uniquely contemporary color phenomenon that carries a lot of baggage.

B 1950s Pink Telephone. © Carin Krasner/CORBIS.

A Portia Munson. *Pink Project* (detail). 1994. New Museum Installation. Found pink objects. Yoshii Gallery, New York. Copyright © 1994 Portia Munson.

The Red Wheelbarrow

so much depends
upon

a red wheel
barrow

glazed with rain
water

beside the white
chickens.

—William Carlos Williams*

Language is among our most useful technological inventions. It allows us to share nervous systems, record events, and celebrate phenomena. Writers have long used color descriptions to infuse their stories with rich and sensual detail. Could the allied invasion of Normandy Beach be described without khaki, brown sand, and red blood? Could we talk about pomegranates or flamingos without color nomenclature? Language is also used to label color, from the functional "high-intensity blue-green" and the flavorful "avocado, Graham Cracker, and mango" to the ornate "King's Arm Rose Pink, Bison Beige, and Angel Wings."

Many contemporary literary theorists and philosophers believe that we live in language's web and can neither see nor understand the world directly. Only through the constraints of all-powerful "language," narratives that permeate and mediate every aspect of our lives, can we perceive phenomena.

Nevertheless, many visual artists have long sought direct unmediated experience, and many believe that the visual realm exists beyond language's reach. We paint landscapes based on pure perceptual information or abstract paintings in which form is manipulated in direct response to formal events. Barnett Newman proclaimed that aesthetics to him was like ornithology to the birds. Vincent Van Gogh said, "How important it is to know how to mix on the palette those colors which have no name and yet are the real foundation of everything." Does Philip Guston's *Painting* **(A)** exist beyond language?

Artists and designers also utilize language in the visual arts. Stuart Davis painted the word *Champion* across his billboard-inspired pop landscapes **(B).** Each letter is a marvelous invention of color and form. Davis also created a painting with a "word" as its subject matter, a word with a meaning and a musical pronunciation. Conceptual artists later made language supreme. Some took everything "visual" out of their art and left nothing but words. In *Why Are You Here?* **(C),** Barbara Kruger appropriates the power of the newspaper and the political poster and their potent combination of text and image. It is interesting to recall that early Egyptian writing had its roots in images called *pictograms*. At the very origin of written language, words and pictures were one. They remain a potent combination.

* William Carlos Williams, *The Collected Poems of William Carlos Williams: 1909–1939* (New York: New Directions, 1991), 224.

A Philip Guston. *Painting.* 1954. 63¼″ × 60⅛″. Oil on canvas. Museum of Modern Art, New York. Gift of Philip C. Johnson, 1956 (7.1956). Digital image © The Museum of Modern Art/Licensed by SCALA/Art Resource, NY.

B Stuart Davis. *Visa.* 1951. Oil on canvas, 40″ × 52″. Museum of Modern Art, New York. Gift of Mrs. Gertrud A. Mellon. (9.1953). Digital image © The Museum of Modern Art/Licensed by SCALA/ Art Resource, NY. © Estate of Stuart Davis/Licensed by VAGA, New York, NY.

C Barbara Kruger. *Why Are You Here?* 1990. Silkscreen on paper, 191″ × 148″. Collection of the Wexner Center for the Arts, Ohio State University. Copyright © 1990 Barbara Kruger. Photo: Frederick Marsh.

While it appears easy to remember color, *in general* it is considered almost impossible to remember color *exactly*. Red, orange, yellow, and blue are often used to mark the floors of parking garages to help drivers remember the floor on which they parked. Using six shades of green would be much less useful.

BBC blue, Hadrian's Wall grey, haggis brown, Noel Winchel's hair red—the desire to recall colors experienced during a year in Edinburgh is delightfully depicted in this drawing by Spencer Finch **(A).** It humorously points out the frustration involved in color memory; vague words sit in for accurate color.

Figurative or representational painting serves to a large extent as an aid to memory. Before painting and drawing, there was no way of preserving the likeness of people, things, or places not present. From this approach we can view figurative art as a system for noting information. These paintings provide notations that remind us of such details as the shape of the face of a deceased relative or the King of England, the *exact* color of skin, hair, and eyes. Paint on canvas is a mnemonic device of high order.

The correlation of color to other senses, especially sound, has an interesting history. It is easy to see how color and sound connect. Both are waves and both function according to physical laws. Both need physiological sense apparatus to capture and translate them. Painter Wassily Kandinsky experienced music in terms of color **(B).** This phenomenon is known as synesthesia and includes any sensation experienced in one sense modality when a stimulus acts on another modality. Many artists have been inspired by the striking similarities between color and sound, and many have used them as a source for making art.

There have been sound machines that "play" colored lights and color scores based on musical notation. All in all, like alchemy, this particular approach has remained a curiosity.

B Wassily Kandinsky, *Composition VI.* 1913. Oil on canvas, 195 × 300 cm. Copyright SCALA/Art Resource, NY. © 2003 Artists Rights Society (ARS), New York/ADAGP, Paris.

A Spencer Finch, Drawing on Exhibition Catalogue. 1995. Collective Gallery, Edinburgh City Centre.

Since the age of reason, symbolism has been on the wane. This is not to say that color symbolism has ceased to exist. Around the globe it lives on in traditional forms and has also assumed new guises. Seasonal celebrations, such as harvest festivals, continue to influence dress and décor with seasonal color schemes. The yellow-orange of fall and the fresh green of spring remain strong signifiers. Black clothes are still worn at funerals in the United States, and white representing purity is worn by most brides, but white also symbolizes death in China, as does yellow in Burma, so don't expect to find universal symbols. Symbolism is largely national and regional and it is always in flux. Remember, too, symbolism doesn't work at all if the audience doesn't know the code in advance.

Aside from traditional symbolism, new forms are emerging in contemporary culture. Urban street gangs have made good use of color symbolism; the Crips and the Bloods wear blue and red, respectively, and mark their territory with their colors. This might seem like a throwback to tribal warfare, but it is exactly what is done by nations and most large institutions. The military has identifying colors, as Scottish tartans denote clans. Corporations also have colors—IBM is referred to as "Big Blue." These institutions have carefully designed corporate identity packages that require the consistent and extensive use of logos and corporate colors on all letterhead, signage, and advertising. Universities, of course, have colors. When Ohio State meets Michigan in Columbus, scarlet and grey become sacred colors to local football fans.

Symbols shift in meaning as events unfold or as personal experience intervenes. Since September 11, 2001, the U.S. flag has darker undertones **(A).** The colors red, white, and blue today proclaim a proud and deeply wounded nation. The flag flies everywhere now to express solidarity . . . but also to mourn.

If you think color is pure pleasure and universally accepted, think again. An ultra-plain sect of Old Order Amish challenged a Pennsylvania law requiring them to put orange reflectors on the rear of their horse-drawn black buggies. Amish men have been jailed for refusing to display the orange triangle. Their interpretation of the biblical call in Romans 12:2 to live symbol-free and plain forbids the use of color and symbol. In his book *Chromophobia,* David Bachelor discusses the ideological strain in Western culture that has stigmatized color as primitive, feminine, vulgar, decorative, cosmetic, and superficial. Yes, even color can be a contested notion.

A Photo by Gary Hershorn, *September 11: A Testimony.* © 2002 by Reuters. NewsMedia/CORBIS.

The Rhodora
On Being Asked Whence Is the Flower

In May, when sea-winds pierced our solitudes,
I found the fresh Rhodora in the woods,
Spreading its leafless blooms in a damp nook,
To please the desert and the sluggish brook.
The purple petals, fallen in the pool,
Made the black water with their beauty gay;
Here might the red-bird come his plumes to cool,
And court the flower that cheapens his array.
Rhodora! if the sages ask thee why
This charm is wasted on the earth and sky,
Tell them, dear, that if eyes were made for seeing,
Then Beauty is its own excuse for being:
Why thou wert there, O rival of the rose!
I never thought to ask, I never knew:
But, in my simple ignorance, suppose
The self-same Power that brought me there brought you.

—Ralph Waldo Emerson*

Color is one of our most enduring sources of sensual pleasure.

Like eating a fine Belgian chocolate, the experience of color can simply delight the senses. A large field of sun-drenched red tulips can take your breath away, and people travel great distances to see cherry trees blossoming in Washington, D.C., or the autumn leaves in Vermont. We marvel at the delicate and translucent coloration of a baby's skin or the subtle greys of Giorgio Morandi's palette **(A)**.

Venture forth to an outdoor market (**B** is a marvelous floating Thai market) and be reminded of the value of pleasure in daily life—display after display of sensual delights, from mounds of deep red-orange paprika and piles of purple concord grapes and fuzzy yellow and red peaches, to glistening orange salmon and blue-black mussels. There are handmade signs with saturated colors, striped and polka-dot fabrics for sale, and jars of glowing honey. The gallery, the magazine, the fashion runway, the store, the garden **(C)**, the festival **(D)**, and the circus represent very different worlds but share an important attribute: They provide visual pleasure and celebrate the senses.

A Still Life 1954, Giorgio Morandi, Burstein Collection. © Burstein Collection/CORBIS.

* Ralph Waldo Emerson, "The Rhodora" in *The Portable Emerson*, ed. Carl Bode and Malcolm Cowley (New York: Penguin, 1981).

B Thai Boats. Floating Market Thailand.
© TAXI/Getty Images, NY.

C Photographer © Brigette Thomas/Garden Picture
Library, Garden Shed, summer 2002, pg. 39.

D Ebisu-Ichi: God of Wealth Festival photo © Taishi
Hirokawa. *Japan Color*, pg. 192. 1982. Chronicle
Books.

NEW DIRECTIONS

Throughout history, new technologies and new media have challenged and expanded our understanding of color. In the fifteenth century, oil paint expanded upon the limits of tempera paint. In the twentieth century, film and video shifted the emphasis from pigments to light. New media and research offer new opportunities.

Jessica Stockholder is a good example of an artist who is expanding the language of abstract painting through site-specific installation. In *Sweet for Three Oranges* **(A)** she uses paint, 40 Christmas trees, 50 kilos of oranges, 4 bird cages, a brick wall, aircraft cable, butane tanks and heaters, rope, roofing paper, tar, light bulbs, yellow electric cord, PVC piping, angle iron, and a 20.45 × 4.9 meter room. In *Sweet for Three Oranges* the viewer is literally engulfed by the work. Instead of green shapes representing trees, as in a traditional painting, Stockholder allows trees to represent green shapes. If she needs yellow lines, for example, she may utilize industrial electrical cord. Jessica Stockholder's work turns representation on its head, disorientating viewers and energizing color.

New materials, especially in the realm of industrial plastics, resins, and laminates, offer artists and designers a never-ending supply of experimental options. The novel lamp called *Globject* (see page 130) utilizes electroluminescent sheets and soft polyurethane to produce glowing analogous colors.

Jeremy Blake is an artist who synthesizes cinema and abstract painting. He creates continually looping digital animations for projection or wall-mounted plasma screens. Many of

B Jeremy Blake, Group of 12 stills from the storyboard for DVD *Angel Dust* 2001. Courtesy of the artist and Feigen Contemporary Gallery.

his works, like *Angel Dust* (represented here in **B** by a series of still images), might at first appear to be paintings or backlit transparencies. An abstract composition may slowly transform into representational references such as, in this case, the architecture of a ski lodge.

Video, television, film, and web-based work utilize varying displays of luminous color, as well as the elements of time and motion. These electronic kinetic media demand new ways of thinking about color and shape, and they present new problems as well as abundant opportunities. Typography and graphic design, for example, once needed only to be involved with static, still images. Today, on computer monitors and television screens, type moves, changes size and color, and morphs into other forms, necessitating a whole new discipline—motion graphics.

Sensitivity to the attributes of color and awareness of color's use in history not only provide valuable knowledge for practice, but they enrich experience. It remains for you to make color respond to tomorrow's unique and specific needs and up to you to invent new approaches to color of the future.

A Jessica Stockholder, *Sweet for Three Oranges.* 1995. Installation view, Fundacio "La Caixa," Barcelona, Spain, 1995. Photo courtesy of Gorney Bravin & Lee, New York.

Abstraction A visual representation that may have little resemblance to the real world. Abstraction can occur through a process of simplification or distortion in an attempt to communicate an essential aspect of a form or concept.

Achromatic Black, grey, or white with no distinctive hues. (See Neutral color.)

Additive mixture The color resulting from the combination of different wavelengths of light. The additive primaries of light (red, green, and blue) when projected together on a white ground produce white light.

Additive system A color mixing system in which combinations of different wavelengths of projected light create visual sensations of color.

Aerial perspective See atmospheric perspective.

Aesthetics A branch of philosophy concerned with the beautiful in art and how it is experienced by the viewer.

Afterimage Occurs after staring at an area of intense color for a certain amount of time and then quickly glancing away toward a white surface where the complementary color seems to appear.

Allover pattern A composition that distributes emphasis uniformly throughout the two-dimensional surface by repetition of similar elements.

Analogous colors A color scheme that combines several hues located next to each other on the color wheel.

Assemblage An assembly of found objects composed as sculpture (see Collage).

Asymmetrical balance Balance achieved with dissimilar forms that have equal visual weight or equal eye attraction.

Atmospheric perspective The perception of less distinct contours as forms recede into the background. Colors appear to be washed out in the distance or take on the color of the atmosphere.

Balance The equilibrium of opposing or interacting forces in a pictorial composition.

Bauhaus The influential school of art and design established in Weimar, Germany, in 1919. The Bauhaus fostered functional design and experiential learning free of preconceptions.

Binder The vehicle in paint, such as oil or acrylic resin, in which pigment is suspended.

Biomorphic Describes shapes derived from organic or natural forms.

Camouflage The act or result of disguising or hiding objects through the utilization of deceptive form and coloration.

Chiaroscuro The use of light and dark values to imply depth and volume in a two-dimensional work of art.

Chroma See Intensity.

Chromatic Relating to the hue or saturation of color.

Collage An artwork created by assembling and pasting a variety of materials to a two-dimensional surface.

Color constancy The psychological compensation for changes in light when observing a color. A viewer interprets the color to be the same under various light conditions.

Color discord A perception of dissonance or harshness in a color relationship. The opposite of harmony.

Color harmony Any one of a number of pleasing color relationships based on groupings within the color wheel (see Analogous colors, Color triad, and Complementary). The opposite of discord.

Color symbolism Employing color to signify concepts or human character traits.

Color transposition When the visual relationship of two or more colors is maintained even when those colors are altered. Similar to "key" in music.

Color triad Three colors equidistant on the color wheel.

Complementary A color scheme incorporating opposite hues on the color wheel. Complementary colors accentuate each other in juxtaposition and neutralize each other in mixture.

Composition The overall arrangement and organization of visual elements on the two-dimensional surface.

Conceptual Artwork based on an idea. An art movement characterized by the primacy of the concept.

Cones Color sensitive cells in the retina.

Constancy effect The perception that objects and spaces have fixed colors, despite the fact that light in flux is constantly altering the color of surfaces.

Content An idea conveyed through the artwork that implies subject matter, story, or information.

Curvilinear Rounded, curving forms, and flowing shapes and compositions.

Design A planned arrangement of visual elements to construct an organized visual pattern.

Diffraction The bending of light waves as they pass around obstacles or through apertures, sometimes resulting in a spectrum.

Distortion A departure from an accepted perception of a form or object. Distortion often manipulates established proportional standards.

Earth colors Colors made from pigments extracted from regional clay deposits, such as Siennas and Umbers that denote their cities of origin.

Emotional color A subjective approach to color usage to elicit an emotional response in the viewer.

Enigmatic Puzzling or cryptic in appearance or meaning.

Equilibrium Visual balance between opposing compositional elements.

Equivocal space An ambiguous space in which it is hard to distinguish the foreground from the background. Your perception seems to alternate from one to the other.

Expressionism An artistic style in which an emotion is more important than adherence to any perceptual realism. It is characterized by the exaggeration and distortion of objects in order to evoke an emotional response from the viewer.

Fauve An artistic style characterized by the use of bright and intense expressionistic color schemes. From a French term meaning "wild beast."

Figurative painting Painting based on the reproduction of appearance.

Figure Any positive shape or form noticeably separated from the background (the negative space).

Focal point A compositional device emphasizing a particular area or object.

Form When referring to objects, it is the shape and structure of a thing. When referring to two-dimensional artworks, it is the visual aspect of composition, structure, and the work as a whole.

Formal Pertaining to the form of an art work or artifact.

Fresco A mural painting technique in which pigments mixed in water are used to form the desired color. These pigments are then applied to wet lime plaster, thereby binding with and becoming an integral part of a wall.

Gestalt A unified configuration or pattern of visual elements that cannot be derived from a simple summation of its parts.

Gesture A line that moves freely. Such lines record the movement of the maker's hand as well as implying motion in the form.

Glaze A thin layer of transparent color applied to the surface of a painting.

Graphic Forms drawn or painted onto a two-dimensional surface. Any illustration or design.

Grid A network of horizontal and vertical intersecting lines that divide space and create a framework.

Ground The surface of a two-dimensional design that acts as the background or surrounding space for the "figures" in the composition.

Harmony The pleasing combination of parts that constitute a composition or component.

Hue A property of color defined by distinctions within the visual spectrum or color wheel. "Red," "blue," "yellow," and "green" are examples of hue names.

Idealism An artistic theory in which the world is not reproduced as it is, but as it should be. All flaws, accidents, and incongruities of the visual world are corrected.

Imbalance Occurs when opposing or interacting forms are out of equilibrium in a pictorial composition.

Impasto A painting technique in which paint is applied in thick layers or strokes to create a rough three-dimensional paint surface.

Implied line An invisible line created by positioning a series of points so that the eye will connect them and thus create movement across the picture plane.

Impressionism An artistic style that sought to recreate the artist's perception of the changing quality of light and color in nature.

Inherent value The natural value of colors as they appear in the spectrum. Spectral blue is darker than yellow, for example.

Installation A mixed-media artwork that is created on site and utilizes space and the existing environment.

Intensity The saturation of hue perceived in a color. For example, fire red is more intense than brick red.

Interface design The design of visual displays or machine control panels located at the boundary where users interact with computers and other machines.

Interference The process in which two or more light waves of the same frequency interact to reinforce or cancel each other.

Interpenetration When colors are presented in a stepped gradation, each step reads as a mixture of the two adjacent colors. Each step appears to be blended from its adjacent colors and reversed.

Iridescence The display of intense, shifting hues, as seen on such surfaces as hummingbird feathers and soap bubbles.

Juxtaposition When one image or shape is placed next to or in comparison to another image or shape.

Kinetic Artworks that actually move or have moving parts.

LED Light-emitting diode, a semiconductor diode used for electronic equipment such as the displays on digital watches and calculators.

Linear perspective A spatial system used in two-dimensional artworks to create the illusion of space. It is based on the perception that if parallel lines are extended to the horizon line, they appear to converge and meet at a common point, called the vanishing point.

Local color The identifying color perceived in ordinary daylight.

Luminosity The quality of radiating or reflecting light, illumination. Also, the degree of brightness of light.

Medium The tools or materials used to create an artwork.

Minimalism An artistic style that stresses essential form above subject matter, emotion, or other extraneous elements.

Mixed media The combination of two or more different media in a single work of art.

Monochrome painting A genre of modern minimalist painting that employs a single field of color per panel.

Monochromatic A color scheme using only one hue with varying degrees of value or intensity.

Montage A recombination of images from different sources to form a new picture.

Negative space Unoccupied areas or empty space surrounding the objects or figures in a composition.

Neutral color Black, white, or grey. (See Achromatic.)

Nonobjective A type of artwork with absolutely no reference to, or representation of, the natural world. The artwork is the reality.

Objective Having to do with reality and fidelity to perception.

One-point perspective A system of spatial illusion in two-dimensional art based on the convergence of parallel lines to a common vanishing point usually on the horizon.

Opaque A surface impenetrable by light.

Open form The placement of elements in a composition so that they are cut off by the boundary of the design. This implies that the picture is a partial view of a larger scene.

Optical mixture Dense areas of small spots of color blend in our perception to form new colors and gradations.

Partitive mixture See Optical mixture.

Pattern The repetition of a visual element or module in a regular and anticipated sequence.

Picture plane The two-dimensional surface on which shapes are organized into a composition.

Pigment A powdered, insoluble, colored substance that is suspended in a liquid binder to make paint.

Plane The two-dimensional surface of a shape.

Pointillism A system of color mixing based on the juxtaposition of small bits of pure color. Also called divisionism.

Polychrome Objects painted in more than one color, or decorated in numerous colors.

Pop art An art movement originating in the 1960s that sought inspiration from everyday popular culture and the techniques of commercial art.

Postmodernism A late twentieth-century ideology that reacts to or rejects modernist beliefs such as progress, originality, or the privileging of form over content.

Positive shape Any shape or object distinguished from the background.

Primary colors The three colors from which all other colors can theoretically be mixed. The primaries of pigments are traditionally presented as red, yellow, and blue, while the primaries of light are red, blue, and green.

Prism A transparent geometric solid, commonly a triangular glass object, that splits white light into a spectrum.

Product semantics The branch of product design that deals with the nature of messages conveyed by artifacts.

Proportion Size measured against other elements or against a mental norm or standard.

Proximity The degree of closeness in the placement of elements.

Push-pull The notion, popularized by the painter and teacher Hans Hofmann, that warm colors appear to advance and cool colors appear to recede, creating a virtual three-dimensional dynamic.

Realism A type of art based on the faithful reproduction of appearance.

Rectilinear Composed of straight lines.

References The associations created by shapes, color combinations, images, and texts.

Reflect To cast back light from a surface.

Refract The bending of light as it travels obliquely from one medium to another, changing speeds. It is due to refraction that white light passing through a prism spreads out to become spectral hues.

Repetition Using the same visual element over again within the same composition.

Representational An image suggestive of the appearance of an object that actually exists.

Retina The inner surface at the back of the eye on which images are projected. The retina, sensitive to light and color, sends the information it gathers to the brain for processing.

Retinal fatigue Due to the physiology of the retina, looking at a color results in a decreasing sensitivity to that color. Retinal fatigue is responsible for numerous visual phenomena, such as simultaneous contrast.

Rhythm An element of design based on the repetition of recurrent motifs.

Rods Light sensitive cells in the retina that enable us to distinguish value in dim light.

Saturation See Intensity.

Scale The proportion of a representation to its original, or of an object in relationship to its environment. Relative size.

Secondary color A mixture of any two primary colors.

Sfumato See Atmospheric perspective.

Shade A hue mixed with black.

Shape A visually perceived area created either by an enclosing line or by color and value changes defining the outer edges.

Silhouette The area between the contours of a shape.

Simultaneous contrast The effect created by two complementary colors seen in juxtaposition. Each color seems more intense in this context.

Site specific A work of art in which the content and aesthetic value is dependent on the artwork's location.

Solvent A liquid that dissolves a substance. Mineral spirits, for example, is a solvent used with oil paint.

Spectral hue A color of the visible spectrum from red, orange, yellow, green, and blue, to violet.

Spectrum The range of visible and invisible wavelengths created when white light is passed through a prism.

Split complementaries A color and the two colors across from it on the color wheel that are adjacent to the color's complement.

Staccato Abrupt changes and dynamic contrast within the visual rhythm.

Subject The content of an artwork.

Subjective Reflecting a personal bias.

Subtractive mixture The color that results when different pigments or dyes are mixed, or when transparent filters are superimposed. Subtractive mixtures are always darker than the parent colors. The subtractive primaries (cyan, magenta, and yellow) when mixed together produce a color that approaches black.

Subtractive system A color mixing system in which pigment (physical substance) is combined to create visual sensations of color. Wavelengths of light absorbed by the substance are subtracted, and the reflected wavelengths constitute the perceived color.

Surrealism An artistic style that stresses fantastic and subconscious approaches to art making and often results in images that cannot be rationally explained.

Symbol An element of design that communicates an idea or meaning beyond that of its literal form.

Symmetry A quality of a composition or form wherein there is a precise correspondence of elements on either side of a center axis or point.

Synesthesia A sensation produced in one sense modality when a stimulus acts on another modality, such as hearing a sound when perceiving a color.

Tactile texture The use of materials to create a surface that can actually be felt or touched.

Tertiary A mixture of a primary and an adjacent secondary color.

Texture The surface quality of objects that appeals to the tactile sense.

Tint A hue mixed with white.

Tonality A single color or hue that dominates the entire color structure despite the presence of other colors.

Tone A hue mixed with its complement.

Translucent A situation in which objects, forms, or planes transmit and diffuse light but have a degree of opacity that does not allow clear visibility through the form.

Transparency A situation in which an object or form allows light to pass through it. In two-dimensional art, two forms overlap, but they are both seen in their entirety.

Triadic A color scheme involving three equally spaced colors on the color wheel.

Tri-chromatic The three-color basis of human perception, the primary colors of light—red, blue, and green.

Trompe l'oeil A French term meaning "to fool the eye." The objects are in sharp focus and delineated with meticulous care to create an artwork that almost fools the viewer into believing that the images are the actual objects.

Typographical design The design of letter forms and alphabets in graphic design.

Unity The degree of agreement existing among the elements in a design.

Value A measure of lightness or darkness.

Value emphasis When a light and dark contrast is used to create a focal point within a composition.

Value pattern The arrangement and amount of variation in light and dark values independent of any colors used.

Vanishing point In linear perspective, the point at which parallel lines appear to converge on the horizon line. Depending on the view, there may be more than one vanishing point.

Vernacular A prevailing or commonplace style in a specific geographical location, group of people, or time period.

Vibrating borders Colors borders that create a flickering effect. This is usually dependent on a close value relationship and strong hue contrast.

Visible spectrum The range of visible color created when white light is passed through a prism.

Visual color mixing The optical mixture of small units of color so that the eye perceives the mixture rather than the individual component colors.

Visual texture A two-dimensional illusion suggestive of a tactile quality.

Warm color A color that appears to be closer to the yellow-to-red side of the color wheel.

Watercolor Paint consisting of pigment and water.

Wavelength In light, the distance between two consecutive light wave peaks. This distance determines hue.

General

Arnason, H. H. *History of Modern Art.* 3rd ed. New York: Harry N. Abrams, 1986.

Berger, John. *Ways of Seeing.* London: British Broadcast Corporation, 1987.

Chipp, Herschel B. *Theories of Modern Art: A Source Book by Artists and Critics.* 3rd ed. Berkeley and Los Angeles, CA: University of California Press, 1971.

Gardner, Louise. *Art through the Ages.* 9th ed. Fort Worth, TX: Harcourt Brace College Publishers, 1995.

Henri, Robert. *The Art Spirit.* 11th ed. Philadelphia and New York: J. B. Lippincott Co., 1958.

Irtel, Prof. Dr. Hans. Mannheim, Germany: University of Mannheim. http://www.uni-mannheim.de/fakul/psycho/irtel/

Janson, H. W. *History of Art.* 4th ed. New York: Harry N. Abrams, 1991.

Mayer, Ralph. *The Artist's Handbook of Materials and Techniques.* New York: Viking Press, 1970.

The International Center of Photography Encyclopedia of Photography. New York: Pound Press, Crown Publishers, 1984.

Tufte, Edward R. *Envisioning Information.* Cheshire, CT: Graphics Press, 1990.

Tufte, Edward R. *Visual Explanations: Images and Quantities, Evidence and Narrative.* New Haven, CT: Graphics Press, 1996.

Wallis, Brian, ed. *Art After Modernism: Rethinking Representation.* New York: The New Museum of Contemporary Art, 1984.

Design

Bevlin, Marjorie Elliot. *Design Through Discovery.* 6th ed. Fort Worth, TX: Harcourt Brace College Publishers, 1994.

De Sausmarez, Maurice. *Basic Design: The Dynamics of Visual Form.* Blue Ridge Summit, PA: TAB Books, 1990.

Hoffman, Armin. *Graphic Design Manual.* New York: Van Nostrand Reinhold, 1977.

Hurlburt, Allen. *The Design Concept.* New York: Watson-Gupthill Publications, 1981.

Hurlburt, Allen. *Layout: The Design of the Printed Page.* New York: Watson-Guptill Publications, 1977.

Itten, Johannes. *Design and Form: The Basic Course at the Bauhaus.* 2nd ed. New York: Van Nostrand Reinhold, 1975.

Kepes, Gyorgy. *Language of Vision.* Chicago: Paul Theobald, 1969.

Kerlow, Isaac Victor, and Judson Rosebush. *Computer Graphics.* New York: Van Nostrand Reinhold, 1986.

Lauer, David A., and Stephen Pentak. *Design Basics.* 5th ed. Fort Worth, TX: Harcourt College Publishers, 2000.

Maier, Manfred. *Basic Principles of Design.* New York: Van Nostrand Reinhold, 1977.

McKim, Robert H. *Thinking Visually.* New York: Van Nostrand Reinhold, 1980.

Murphy, Pat. *By Nature's Design.* San Francisco: Chronicle Books, 1993.

Visual Perception

Arnheim, Rudolf. *Art and Visual Perception: A Psychology of the Creative Eye, the New Version.* 2nd ed. Berkeley: University of California Press, 1974.

Bloomer, Carolyn M. *Principles of Visual Perception.* 2nd ed. New York: Van Nostrand Reinhold, 1989.

Carraher, Ronald G., and Jacqueline B. Thurston. *Optical Illusions and the Visual Arts.* New York: Reinhold, 1966.

Gombrich, E. H. *Art and Illusion: A Study in the Psychology of Pictorial Representation.* Princeton, NJ: Princeton University Press, 1961.

Gregory, Richard L. *Eye and the Brain: The Psychology of Seeing.* London: Weidenfeld and Nicolson, 1971.

Luckiesh, M. *Visual Illusions: Their Causes, Characteristics and Applications.* New York: Dover Publications, 1965.

Color

Albers, Josef. *Interaction of Color.* Rev. ed. New Haven, CT: Yale University Press, 1975.

Batchelor, David. *Chromophobia.* London: Reaktion Books Ltd., 2000.

Beck, Jacob. *Surface Color Perception.* Ithaca, NY, and London: Cornell University Press, 1972.

Berger, John, and John Christie. *I Send You This Cadmium Red . . . A Correspondence Between John Berger and John Christie.* Barcelona: ACTAR in collaboration with MALM.

Birren, Faber. *Creative Color: A Dynamic Approach for Artists and Designers.* New York: Van Nostrand Reinhold, 1961.

Birren, Faber. *Ostwald: The Color Primer.* New York: Van Nostrand Reinhold, 1969.

Birren, Faber, ed. *Munsell: A Grammar of Color.* New York: Van Nostrand Reinhold, 1969.

Birren, Faber, ed. *Itten: The Elements of Color.* New York: Van Nostrand Reinhold, 1970.

Birren, Faber. *Principles of Color.* Rev. ed. West Chester, PA: Schiffer Publishing, Limited, 1987.

Carpenter, James M. *Color in Art: A Tribute to Arthur Pope.* Cambridge, MA: Fogg Art Museum, Harvard University, 1974.

Chevreul, Michel Eugène. *The Principles of Harmony and Contrast of Colors and Their Application to the Arts.* New York: Reinhold Publishing Corp., 1967.

De Grandis, Luigina. *Theory and Use of Color.* New York: Harry N. Abrams, 1987.

Evans, Ralph M. *An Introduction to Color.* 4th ed. New York: John Wiley and Sons, Inc., 1965.

Fabri, Frank. *Color: A Complete Guide for Artists.* New York: Watson-Guptill, 1967.

Gage, John. *Colour and Culture: Practice and Meaning from Antiquity to Abstraction.* London: Thames and Hudson, 1993.

Gage, John. *Colour and Meaning.* London: Thames and Hudson, 1999.

Gerritsen, Frans. *Theory and Practice of Color.* New York: Van Nostrand Reinhold, 1974.

Itten, Johannes. *The Art of Color.* Rev. ed. New York: Van Nostrand Reinhold, 1989.

Itten, Johannes. *The Elements of Color.* New York: Van Nostrand Reinhold, 1970.

Kandinsky, Wassily. *Concerning the Spiritual in Art.* New York: Dover Publications Inc., 1977.

Kippers, Harald. *Color: Origin, Systems, Uses.* New York: Van Nostrand Reinhold, 1973.

Koolhaas, Rem, and Norman Foster and Alessandro Mendini. *Colours.* The Netherlands: V + K Publishing, 2001.

Mejetta, Mirko, and Simonetta Spada. *Interiors in Color.* New York: Watson-Guptill Publications, 1983.

Munsell, A. H. *A Color Notation.* 14th ed. Baltimore, MD: Munsell Color, Macbeth, a division of Kollmorgen Corp., 1981.

Newton, Sir Isaac. *New Theory About Light and Colors.* Munich: W. Fritach, 1967.

Porter, Tom, and Byron Mikellides. *Color for Architecture.* New York: Van Nostrand Reinhold Company, 1976.

Rood, Ogden N. *Modern Chromatics: A Student's Textbook of Color with Application to Art and Industry.* New ed. New York: Van Nostrand Reinhold, 1973.

Varley, Helen, ed. *Color.* Los Angeles: Knapp Press, 1980.

Verity, Enid. *Color Observed.* New York: Van Nostrand Reinhold, 1980.

von Goethe, Johann W. *Theory of Colours.* Cambridge, MA: MIT Press, 1963.

Zelanski, Paul, and Mary Pat Fisher. *Color.* Englewood Cliffs, NJ: Prentice-Hall, 1989.

The authors and the publisher wish to thank the custodians of the works of art for supplying photographs and granting permission to use them.

Chapter 1

p. 3 © 2003 Milton Avery Trust/Artists Rights Society (ARS), New York.

p. 4 Imaging and Photograhic Technology, Rochester Institute of Technology.

p. 5 © Andy Goldsworthy.

p. 7 top, National Eye Institute, National Institute of Health.

p. 7 both, Richmond Products, Inc.

p. 9 Courtesy of The Sherwin-Williams Company.

p. 11 bottom, Photo courtesy of the authors.

p. 13 top, Courtesy of Ferrari North America, Inc.

p. 13 bottom, © Royalty-Free/CORBIS.

p. 15 top, Photo: Hervé Lewandowski. Copyright Réunion des Musées Nationaux/Art Resource, NY.

p. 15 bottom, © 2003 Museum of Fine Arts, Boston.

Chapter 2

p. 17 Newton's Color Wheel from *Newton*, 1704, Book I, Part II, Plate III.

p. 20 Courtesy of American High Definition, Inc.

p. 21 top, George Eastman House.

p. 21 bottom, Copyright © 1943 by Jan Groover. Cleveland Museum of Art. Date: 1986. Purchased with a grant from the NEA and matched by contributions from Museum members in 1989 (1989.439).

p. 23 top, © AFP/CORBIS.

p. 23 bottom, Photo by Howie Meyer.

p. 25 top, Courtesy of GretagMacBeth, LLC, New Windsor, NY.

p. 29 from Runge, *Die Farbenkugel*, Hamburg, 1810.

p. 31 Courtesy of the Ostwald Institute. www.wilhelm-ostwald.de.

p. 33 Courtesy of GretagMacBeth, LLC, New Windsor, NY.

p. 35 Courtesy of Carl R. Nave, Georgia State University.

p. 37 top, Courtesy of Pantone.

p. 37 bottom, Courtesy of Gary W. Priester.

Chapter 3

p. 43 Courtesy of the authors.

p. 44 Image © 2003 Board of Trustees, National Gallery of Art, Washington.

p. 45 Image © 2003 Board of Trustees, National Gallery of Art, Washington.

p. 46 top, Copyright Erich Lessing/Art Resource, NY.

p. 47 Copyright Erich Lessing/Art Resource, NY.

p. 49 top, Copyright Erich Lessing/Art Resource, NY.

p. 49 bottom, Copyright Réunion des Musées Nationaux/Art Resource, NY.

p. 51 Collection of Walker Art Center, Minneapolis. Gift of Elizabeth McFadden, 1979. Accession number 1979.4.

p. 53 Courtesy of Karl Gerstner. From *The Spirit of Colors: The Art of Karl Gerstner*, 1981 MIT Press. p. 179.

p. 55 Collection of The Butler Institute of American Art, Youngstown, Ohio.

p. 57 top, Photo by Michael A. Corley, www.frisco.org., Dallas, TX.

p. 57 bottom, Courtesy Wentworth Shire Council, NSW, Australia.

p. 59 Artist Wes Wilson. Collection of Paul Olsen—olsenart.com.

p. 61 Courtesy House of Tartan.

p. 63 From *Treasury of American Quilts* by Cyril I. Nelson and Carter Houck, Greenwich House, 1982, p. 53.

p. 64 Courtesy House of Tartan.

p. 65 Museum of Anthropology, University of Kansas.

Chapter 4

p. 66 Collection of the Modern Art Museum of Fort Worth, The Beth Collins Memorial Trust. © 2003 Andy Warhol Foundation for the Visual Arts/ARS, New York.

p. 67 The Andy Warhol Foundation, Inc./Art Resource, NY. © 2003 Andy Warhol Foundation for the Visual Arts/ARS, New York.

p. 69 Library of Congress. © Romare Bearden Foundation/ Licensed by VAGA, New York, NY.

p. 70 © 2003 Monika Sprüth Gallery, Colgone/Artists Rights Society (ARS), New York/VG Bild-Kunst, Bonn. Courtesy the artist and Matthew Marks Gallery, New York.

p. 71 Digital Image © The Museum of Modern Art/Licensed by SCALA/Art Resource, NY. © 2003 Mondrian/Holtzman Trust/Artists Rights Society (ARS), New York.

p. 72 From Karl Blossfeldt Working Collages, Plate 29, The MIT Press, Cambridge, MA.

p. 73 Collection of the Modern Art Museum of Fort Worth, Museum purchase, Sid W. Richardson Foundation Endowment Fund. Courtesy of Mark Tansey.

p. 74 Courtesy of BP p.l.c.

p. 75 Worcester Art Museum, Worcester, Massachusetts, Alexander H. Bullock Fund.

p. 77 © David Hockney.

p. 79 The Howard University Gallery of Art.

p. 81 Statens Museum for Kunst, Copenhagen. Photographer: DOWIC Fotografi © 2003. © 2003 Succession H. Matisse, Paris/Artists Rights Society (ARS), New York.

p. 83 Brauer Museum of Art, 53.01.226, Valparaiso University.

p. 85 Sheldon Memorial Art Gallery and Sculpture Garden, University of Nebraska–Lincoln. Nebraska Art Association, Thomas C. Woods Memorial. © 2003 The Josef and Anni Albers Foundation/Artists Rights Society (ARS), New York.

p. 87 The Metropolitan Museum of Art, Purchase, Gift of Mr. and Mrs. Richard Rogers, by exchange, and Francis Lathrop Fund, 1963. (63.225) Photograph © 1999 The Metropolitan Museum of Art.

p. 89 Copyright Tate Gallery, London/Art Resource, NY.

p. 91 Digital Image © The Museum of Modern Art/Licensed by SCALA/Art Resource, NY. © Neil Welliver, Courtesy Alexandre Gallery, New York.

p. 93 © Lewis Baltz.

p. 95 top, United Nations. © 2003 Artists Rights Society (ARS), New York/ADAGP, Paris.

p. 95 middle, © Gamblin Artists Colors Co.

p. 95 bottom, The Phillips Collection, Washington, DC. © 2003 Artists Rights Society (ARS), New York/ADAGP, Paris.

p. 97 © Chuck Close and Pace Editions, Inc.

p. 99 top, Museo del Prado, Madrid. Scala/Art Resource, NY.

p. 99 bottom, Photography by David Heald ©The Solomon R. Guggenheim Foundation, New York. © 2003 Artists Rights Society (ARS), New York.

p. 100 © Alex Katz/Licensed by VAGA, New York, NY.

p. 101 Courtesy Gagosian Gallery, London.

p. 102 © 2003 Museum of Fine Arts, Boston.

p. 103 Anders/Staatliche Museen zu Berlin-PreuBischer Kulturbesitz, Gemäldegalerie/Kaiser-Friedrich-Museums-Verein.

p. 104 Courtesy Jay and Susen Leary. From *A Gallery of Amish Quilts* by Robert Bishop and Elizabeth Safanda, copyright 1976 by E. P. Dutton & Co., Inc. Used by permission of Dutton, a division of Penguin Group (USA) Inc.

p. 105 School of American Research, Catalogue Number IAF.T734.

p. 107 Courtesy of The Kroger Co.

Chapter 5

p. 109 Photo by Oren Slor. Courtesy of the artist and Feature Inc., New York.

p. 110 Photo courtesy of Taylor Dabney.

p. 111 © Scott Richter, courtesy of Elizabeth Harris Gallery, NY.

p. 112 © Anne Truitt.

p. 113 © Carolina Biological Supply Company. Used with permission.

p. 114 © Alinari/SEAT/Art Resource, NY.

p. 115 Jeff Koons Productions, Inc.

p. 117 top, © Jan Moline/Photo Researchers, Inc.

p. 117 bottom, Photo Hans Werlemann/MVRDV.

p. 119 © Publications International, Ltd.

p. 120 © Close Murray/CORBIS Sygma.

p. 121 Photo credit (c) Carol Rosegg.

p. 123 top, Photo © Giorgio Colombo, Milano.

p. 123 bottom, Whitney Museum of American Art, New York; 50th Anniversary Gift of Mr. and Mrs. Albert Hackett in honor of Edith and Lloyd Goodrich. 84.31.

p. 124 © Heather Angel/Natural Visions.

p. 125 © Scott Frances/Esto.

p. 127 Courtesy of The Finnish Glass Museum.

p. 129 Courtesy of James Carpenter Design Associates.

p. 130 Courtesy of Karim Rashid, Inc.

p. 131 Photography by David Joseph.

p. 132 Versus Versace Ad, inside front cover, *Wallpaper,* May 2002, p. 1.

p. 133 top, Courtesy Paula Cooper Gallery, New York.

p. 133 bottom, Dallas Museum of Art, gift of Gerald Gulotta.

p. 134 Courtesy of Dansk Design Center.

p. 135 Courtesy David Batterham.

p. 137 Hancock Shaker Village, Pittsfield, MA. Photograph by Michael Fredericks.

p. 138, © Photopia.

p. 139 top left, Cooper-Hewitt, National Design Museum, Smithsonian Institution, Photo: Dave King.

p. 139 bottom left, Courtesy Jean Philippe Lenclos.

p. 139 right, PurTest® Nitrate/Nitrite Water Test Strips color chart provided by American Water Service, Matthews, NC. © Copyright American Water Service.

p. 140 Photograph by George Kopp.

p. 141 Copyright Art Resource, NY. © 2003 Estate of Alexander Calder/Artists Rights Society (ARS), New York.

p. 143 © Michael Moran.

Chapter 6

p. 144 © Staffen Widstrand/CORBIS.

p. 145 Copyright © 2002 by John Uher.

p. 147 © Chin Fah Shin.

p. 148 © Heather Angel/Natural Visions.

p. 149 top, Copyright © 2002 Conde Nast Publications. Reprinted with permission.

p. 149 bottom, © Dr. Paul A. Zahl/Photo Researchers.

p. 151 The Phillips Collection, Washington, DC.

p. 153 © Photo B.V.C./CORBIS.

p. 154 © Carin Krasner/CORBIS.

p. 155 Copyright © 1994 Portia Munson.

p. 157 top left, Digital Image © The Museum of Modern Art/Licensed by SCALA/Art Resource, NY.

p. 157 top right, Digital Image © The Museum of Modern Art/Licensed by SCALA/Art Resource, NY. © Estate of Stuart Davis/Licensed by VAGA, New York, NY.

p. 157 bottom, Collection Wexner Center for the Arts. The Ohio State University: 1990. Copyright © 1990 Barbara Kruger. Photo: Fredrick Marsh.

p. 158 © SCALA/Art Resource, NY. © 2003 Artists Rights Society (ARS), New York/ADAGP, Paris.

p. 159 Courtesy of the Artist and the Collective Gallery, Edinburgh City Centre.

p. 161 Copyright © Reuters NewsMedia/CORBIS.

p. 162 © Burstein Collection/CORBIS.

p. 163 top, © TAXI/Getty Images, NY.

p. 163 bottom right, © Brigitte Thomas, Garden Picture Library.

p. 163 bottom left, © Taishi Hirokawa Photography.

Afterword

p. 164 Courtesy of the artist and Feigen Contemporary Gallery.

p. 165 Copyright © 1995 Jessica Stockholder. Photo courtesy of Gorney Bravin + Lee, New York.